MW00608798

IMAGES
of America

VINALHAVEN ISLAND'S MARITIME INDUSTRIES

IMAGES
of America

Vinalhaven Island's
Maritime Industries

Cynthia Burns Martin for the
Vinalhaven Historical Society
Foreword by Roy Heisler

ARCADIA
PUBLISHING

Published by Arcadia Publishing
Charleston, South Carolina

Printed in the United States of America

Library of Congress Control Number: 2014938162

For all general information, please contact Arcadia Publishing:
Telephone 843-853-2070
Fax 843-853-0044
E-mail sales@arcadiapublishing.com
For customer service and orders:
Toll-Free 1-888-313-2665

Visit us on the Internet at www.arcadiapublishing.com

This book is dedicated to Roy Heisler and Bill Chilles, two Renaissance men who built an outstanding small museum and scholarly archive on a shoestring budget, preserving Vinalhaven's history and heritage for future generations.

CONTENTS

FOREWORD

Almost 20 years ago, my late wife, Esther Bissell, and I worked with staff of the Vinalhaven Historical Society to produce *Vinalhaven Island* for the Images of America series produced by Arcadia Publishing. Our book was a broad overview of the island's history, with chapters devoted to fishing-related occupations and the granite industry. *Vinalhaven Island's Maritime Industries* is a natural progression from our work, as it focuses on the continuity of the sea in Vinalhaven's economy activity. Fishing and farming provided the livelihood of the earliest settlers in the 1760s, long before the invention of the camera. Most of Vinalhaven's present-day lobstermen are either descended from many generations of fishermen, or they are descended from granite workers who turned to the sea after granite quarries closed.

The granite industry itself was dependent on the sea, as schooners and sloops were the only means of transporting stone to distant markets. Vessel bills of lading in the Vinalhaven Historical Society collection record the ships, cargoes, and ports of destination. The granite industry documented quarrying and finishing processes for marketing. Company photographers had newsworthy subjects when Vinalhaven granite went to renowned structures in many cities, including the eight great columns that went to New York's Cathedral of St. John the Divine, where our historical society held a photographic exhibit in 1999.

The first image of Vinalhaven's fishing fleet in Carver's Harbor was created for the popular stereopticon viewer. Later, with the introduction of postcards, there was a dramatic increase in maritime images created by island photographers like William Merrithew, including vernacular seascapes and landscapes in the style of contemporary Maine photography artists such as Chansonetta Stanley Emmons. With the establishment of fish processing plants in the late 1880s, photographers were hired to document every phase of the operations for publicity and promotion of their wholesale markets. With the rise in home photography in the early 20th century, many tourists visiting Vinalhaven generated images of the fishing industry and the lobster fleet.

Cynthia Burns Martin, professor of business administration at New England College in Henniker, New Hampshire, previously published a study of the Bodwell Granite Company Store. Now she has provided a much-needed look at maritime industries on Vinalhaven, based on primary sources and images from the Vinalhaven Historical Society and other collections.

Enjoy!

—Roy Heisler, director emeritus
Vinalhaven Historical Society

ACKNOWLEDGMENTS

Since Vinalhaven Historical Society was founded in 1963, the organization has pursued its mission of preserving the history of Vinalhaven and nearby islands by building a remarkable collection of images and archival documents of interest to scholars and family historians alike. The society also operates a small, eclectic museum, with permanent and seasonal exhibits of material culture of Vinalhaven's industries and people. The hardworking staff members and volunteers who maintain these collections have a wealth of knowledge and boundless enthusiasm for assisting anyone with a question or interest in local history. Unless otherwise noted, all images appearing in this book were graciously provided by the Vinalhaven Historical Society.

This book is primarily a collection of early images related to Vinalhaven's maritime industries and not intended to be a comprehensive history. Specific individuals and families mentioned in this book were included based on availability of images and are presented as being representative of many other Vinalhaven citizens who contributed to the island's rich maritime history.

I am grateful to Bill Chilles, who gave me the opportunity to pursue this project on behalf of Vinalhaven Historical Society, and the many people and organizations that helped transform an opportunity into reality: Chandler Blackington, Bill Brown, Elizabeth Bunker, Frank Caffrey, Scott Candage, Lauretta Chilles, Caitrin Cunningham, Phil and Sadie Dyer, Diana Roberts Gay, Charlotte Goodhue, Roy Heisler, Maddy Hildings, Marilyn Ingham, Kevin Johnson, Dick Mathews, Sue Dyer Radley, Earle G. Shettleworth Jr., Buddy Skoog, Bob Trapani, Delwyn C. Webster, and Roger W. Young. A number of organizations provided images and source material for this project, including the American Lighthouse Foundation, Ivan Calderwood Homestead, Maine Historic Preservation Commission, and Penobscot Marine Museum. I am thankful that my grandfather Prof. Ralph Arthur Burns taught me to cherish my deep island roots, and my husband, Neal Brian Martin, helped me come home to Vinalhaven. Without their support, this book would not have been possible.

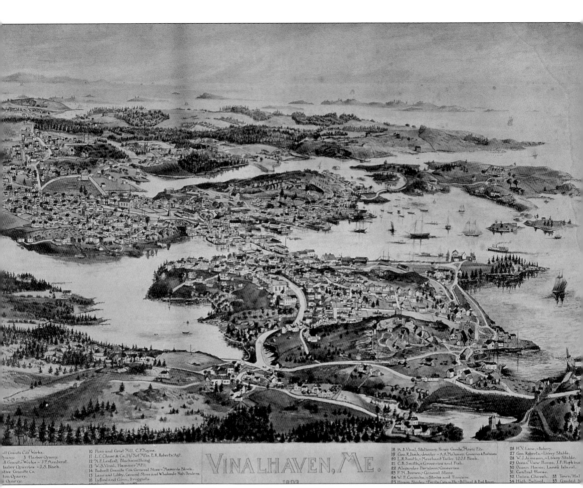

This *Bird's Eye View Map of Vinalhaven* from 1893 shows a prosperous village centered on Carver's Harbor.

INTRODUCTION

Vinalhaven is one of the largest islands in the Penobscot Bay, situated off mid-coast Maine in the path of the Labrador Current, which brings nutrient-rich water south, attracting abundant fish. Outlying banks in the path of the warmer northbound Gulf Stream, such as Georges Bank, lie within a day's sail. Extreme tidal mixing fosters diverse species of marine life for harvest. Prior to recorded history, Native Americans camped at the island in summer to fish, hunt for seal, and gather shellfish. By the late 17th century, Penobscot Bay was being fished for cod by Europeans. Early settlers called the island South Fox Island.

In 1762, twenty-seven men and their families came to the Fox Islands from "the westard," the mainland lying to the west of the islands. They came seeking economic opportunity in what was wild, uncultivated land, but farming shallow topsoil on granite ledge offered little more than a subsistence living. Many quickly turned to cutting firewood for the Boston market or trading in coasters, single-masted sloops or double-masted schooners sufficiently seaworthy for trips to and from the mainland.

Leaving Vinalhaven soil and venturing west to the mainland across 12 miles of water can be a formidable journey even today when the wind is blowing from south-southwest, raising high seas in the open bay. Vinalhaven's commerce and community have always depended on reliable transportation of goods and people to and from the mainland. Some of the island's early settlers had boats that were available for hire. On August 18, 1775, Thaddeus Carver hired Job Philbrook and his boat *Polly* to bring a broken sawmill crank to the mainland for repair and returned a month later on September 17.

The American Revolution disrupted economic activity for the settlers at Fox Islands, most of whom left the island and abandoned their houses and possessions to British troops that ranged Penobscot Bay from their base at what is today Castine, at the mouth of the Bagaduce River. During the war, the British destroyed many of the colony's schooners, impacting the fishing industry for years to come. After the war, settlers returned to the islands, and in 1784, seventy-two settlers (including one African American and two women) successfully petitioned the Commonwealth of Massachusetts for a grant of the land they called North and South Fox Islands, later known as North Haven and Vinalhaven. By 1785, mariner Thomas Ginn was running a freighter between the two islands and Boston, according to the town history.

A significant force in the economic history of Vinalhaven was the federal act of July 4, 1789, that created a bounty for catching, preserving, and exporting codfish, to stimulate exports and appease fishermen for a tax on imported salt used to cure cod. A subsequent act in 1792 added another bounty for vessels and fishermen employed fishing for cod at least four months a year, creating incentive for private owners to rebuild the country's merchant fleet after the Revolutionary War. The vessel bounty was calculated using a base rate multiplied by tonnage of the vessel, with the highest base rates per ton for vessels that exceeded 30 tons. A vessel bounty was divided among owners (three-eighths) and fishermen (five-eighths). Lucrative government bounties, coupled with

the competitive advantage of proximity to rich fishing grounds, made offshore fishing a more attractive investment than farming shallow topsoil in a short growing season.

By 1805, vessels from Vinalhaven ventured north to Labrador, where they launched small boats and fished close to shore. The Bay of Fundy was fished in schooners of less than 40 tons with crews of four to five men. The bounties were briefly repealed in 1807 and reinstated in 1813. By 1819, Benjamin Beverage claimed the Vinalhaven fleet included 700 tons of vessels for cod and herring fishing ranging from 10 to 100 tons. Up to 15 of them were the well-known Chebacco boats built in the Chebacco district of Ipswich. They were small, double-masted craft under 30 tons, with a deck ringed by cockpits, where fishermen stood and threw lines of baited hooks and hauled up fish. Below deck, there was a hold to store the catch. The federal census of 1850 for Vinalhaven recorded that 368 fishermen harvested cod and cod liver oil on 73 vessels held by 26 owners. In 1860, four hundred forty-nine fishermen harvested cod, oil, mackerel, and other fish (probably halibut and hake) on 79 vessels held by 18 owners. Vinalhaven vessels fished in open waters on Cape Sable, Cape Shore, Georges Bank, Seal Island, and Brown's Bank grounds off the southwestern tip of Nova Scotia.

Federal bounties stimulated boatbuilding at the island. One year after the vessel bounty was introduced, 110-ton *Polly* was launched from a North Island boatyard. In the ensuing 15 years, while federal bounties were in place, the Vinalhaven fleet was increased by four boats built at Vinalhaven and six built on North Haven. However, no locally built boats were registered at Vinalhaven during the period when federal bounties were repealed, from 1807 to 1813. During the War of 1812, British privateer vessels interfered with trade, roamed Penobscot Bay, and captured coasters. In 1813, local fishermen retaliated and attacked a British privateer anchored at White Island, off Vinalhaven. With resumption of the federal vessel and fishing bounties, boatbuilding returned to the island in 1813. From 1813 to 1866, while the bounties lasted, 40 vessels built in local boatyards were registered at Vinalhaven.

Federal bounties indirectly fueled another island industry: preservation of fish for export by drying, pickling, and smoking. Codfish has a white flesh with low oil content, so it is easily desiccated with exposure to sun and salt, making it easily preserved for commercial purposes. Salt cod from Vinalhaven was exported to Caribbean plantations and also found markets in the South. According to David Vinal, Vinalhaven alone marketed $70,000 worth of dry fish in 1855. Although there were occasional attempts at establishing saltworks at Vinalhaven, extracting salt from seawater was inefficient and less cost-effective than using salt imported from Spain and Portugal, even with the added cost of federal duties on imported salt.

Compared to cod, oily fish like herring and mackerel are better preserved by smoking or pickling. Magdalen Islands herring caught by the Vinalhaven fleet in the first half of the 19th century were smoked and sold to the Boston market. Fish caught in the offshore fishery were sometimes cured on land closest to where the vessel was anchored, but when possible, Vinalhaven fishermen generally cured their fish at the island and sold them to Boston dealers. On June 14, 1846, William Vinal wrote, "Capt. Turner has arrived with about four hundred BB of Herring and filled my smoak house and left them for me to box and ship, I named to him that I should ship them by you in the *Oregon*."

With federal subsidies, the fishery generated more dependable revenues than the thin, rocky topsoil and uncertain climate of Vinalhaven. Island families grew prosperous from their investments in fishing vessels, boatbuilding, boat outfitting, sail making, curing the catch, and transporting fish to distant markets.

One

THE OFFSHORE FISHERY

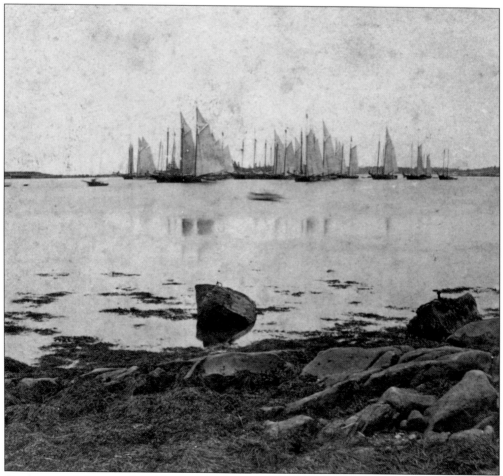

Single-masted sloops and double-masted schooners like these pictured in the mid-1850s were the mainstay of Vinalhaven's fishing fleet during the 19th century. Some vessels had several owners, usually related by blood or marriage, who shared risks and returns. Some owners wisely diversified their investments by holding shares in several vessels. Some captains were also masters of their own ships.

Reuben Carver (1797–1890) and his brother John invested heavily in offshore fishing. There was demand for salt fish, nonperishable and inexpensive protein, on slave plantations in the South and the Caribbean. On February 29, 1848, Reuben wrote John, saying "You stated that you were bound for Savannah and Charleston and Wilmington you did not say whether you was a going to return to Havannah or not but I supposed you will if so I think you had better take freight for some southern port."

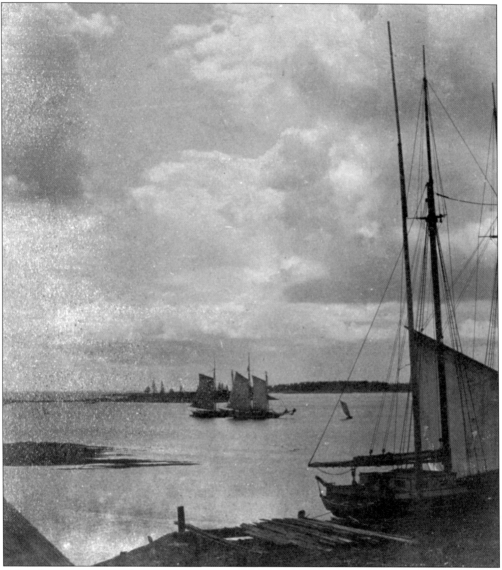

A handwritten note on this stereopticon image indicates these schooners were owned by Reuben Carver, whose prolific boat shop turned out 11 schooners and a brig starting in 1826 with the *Plymouth Rock*. One of these boats may be his last, *Island Home*, lost at sea in 1867. In 1850, Reuben Carver had $4,600 capital invested in three vessels and employed 19 hands. Carver's other businesses included lumbering, curing and smoking fish, and running a sawmill.

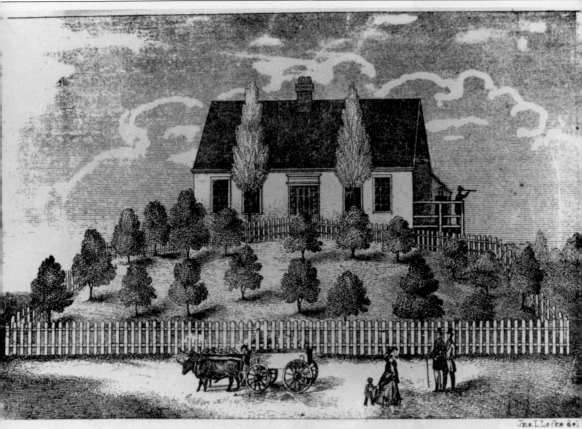

RES. OF CAPT JOHN CARVER
VINALHAVEN.

Jne L Locke del

Capt. John Carver built a fine house on a hill overlooking the harbor. He wrote David Vinall Esq. on May 30, 1846: "Our fisherman are all hauled up being Embargo & for eight days with Eastwardly winds & fog. nothing to do but to catch hardheads & let them pot, and that you know is enough to make them snarl when fresh bate first comes and they are full of spunk for the coming season. I will inform you that the *Potoci* and the *Economy* arrived yesterday deep loaded and I am looking this morning through the easterly wind & mist with my eyes out like a lobsters to get a glimpse at the *Catherine* and *Osceola* but I have not got it yet. My brother is going to Castine to day to fit out the *Louisa* who will take this letter to Castine to mail." Carver was well aware of the dangers at sea and nearly lost his life aboard a ship that was rammed by another vessel.

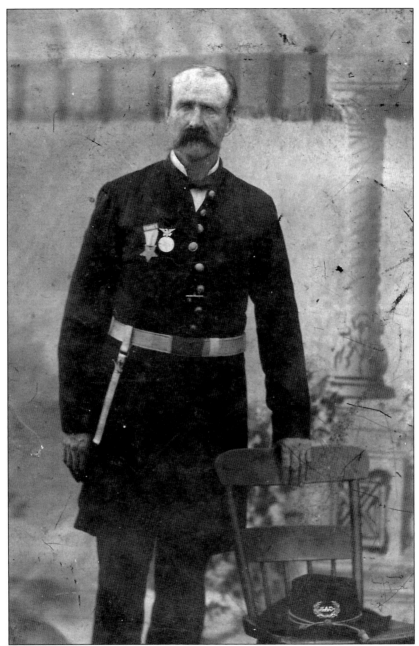

Henry S. "Harry" Hopkins was born in 1834. In this late-19th-century tintype, he is wearing his Grand Army of the Republic uniform. On January 7, 1858, Hopkins married Jane Eliza Carver. On January 18, 1874, Capt. David Carver and his wife, Jane, wrote to his parents (John and Rhoda Carver) from aboard a ship anchored at Leobos de Terre, a guano-rich island off the coast of Peru, saying, "I have been here one week have got my ballast out and 100 tons of guano onboard which is doing well for the place. In loading guano all ships have a large number of laydays the *Treat* takes 64 working days but I am in hopes to buy off 25 or 30 days by paying X3 for every 100 tons of burden . . . I still hope to be away by the 1st of March . . . tell Harry to be all ready to go with me next voyage." Harry was married to Capt. David Carver's younger sister.

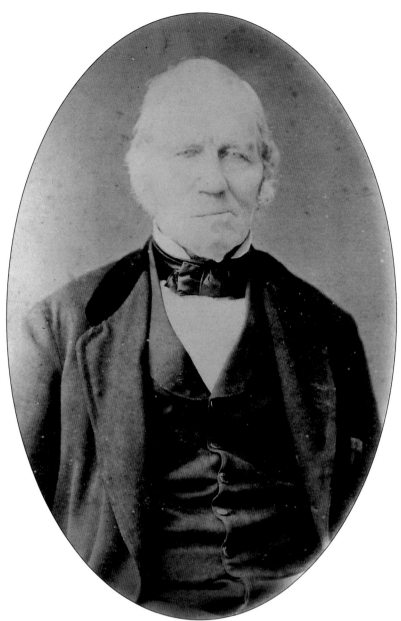

Capt. John Carver was born April 12, 1793, and lived until 1877. Captain Carver invested heavily in offshore fishing and the coasting trade, served on the board of selectmen, and represented Vinalhaven in the legislature. He was a busy man, who dashed off a letter to David Vinall Esq. on June 24, 1846, at the height of the codfish boom: "I have but one moment to write for I must send this to Castine by the *Ceola* who is a going to day after washing out 225 quintals of fish. Conant sails today on his second fare after landing 200 quintals. The *Rival* brought a small fare. She has now gone to the Straights. John Lindsey has gone in company with him or rather William Burgess has gone. Mr. Lindsey was carried on board drunk when they sailed after living a teatotaler one year. How the mighty are fallen. Do all you can for the suppression of ardent spirits. Capt. Mills finishes handing up herring to day. The *Oregon* commences today with fish. Capt. Joseph Lane has sailed with a load of fish last Saturday."

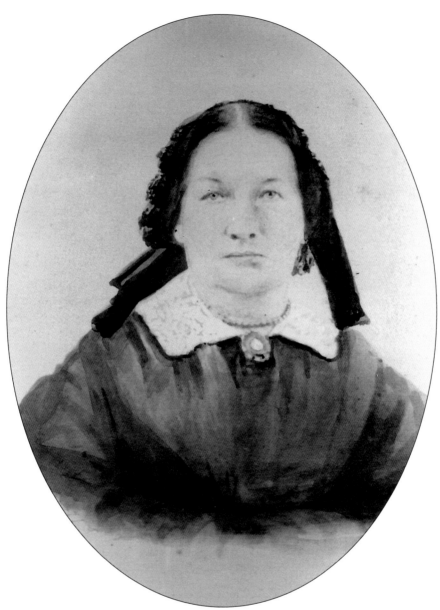

Rhoda Arey was born in 1800 and married Capt. John Carver on January 15, 1818. With her husband often away, she raised their 13 children, including Ebenezer Carver, lost at sea in 1853. Capt. David Carver wrote his parents about Ebenezer from onboard *Eddistone* at New Orleans: "How long he survived on the broken fragments of the little bark will never be known or whether he was swept into eternity without a moment's warning will remain a mystery until the resurrection moment when the sea shall give up her dead." Rhoda's relationships with other villagers may have been strained when the Belfast customs office asked her husband to investigate the rumor "that salt has been brought into North Haven as well as Vinalhaven without being entered or paying duty," and Captain Carver reported: "there is goods secreted on the premises or in the buildings now occupied by Stephen Delano at the Old Harbor . . . to defraud the Revenue of the United States . . . and on Greens Island . . . in buildings occupied by Theophilus Delano . . . and Joseph Arey . . . and Isaiah Bray . . . and Lewis Arey."

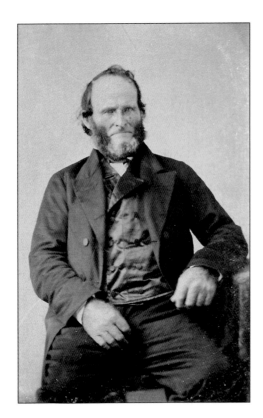

John Smith was the master and owner of many vessels, including the *Heart of Oak* and *Eight Brothers*. He was born April 12, 1793, and died in November 1877.

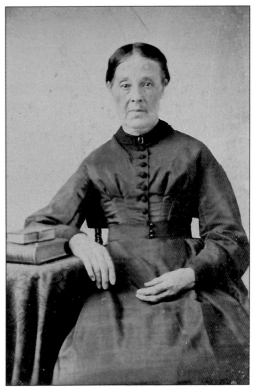

Margaret Laroque Smith married Capt. John Smith on May 7, 1829. She died on December 3, 1873.

Rebecca Smith Lane was the wife of Timothy Lane, Vinalhaven's largest investor in the cod fishing industry. He started by outfitting fishing vessels with provisions and gear. In 1850, he reported to the US Census that he had $8,400 capital invested in six vessels and employed 38 men when the majority of Vinalhaven captains owned one or two vessels and employed four or five hands. By 1860, Lane employed 65 fishermen on 10 sailing vessels.

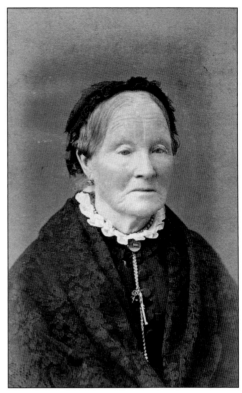

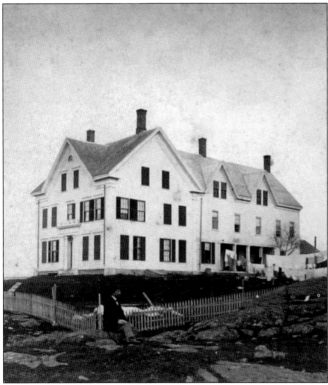

Timothy and Rebecca Lane's imposing mansion on Lane's Island was constructed in fashionable Greek Revival style at the height of the cod fishing boom. (Courtesy of Maine Historic Preservation Commission.)

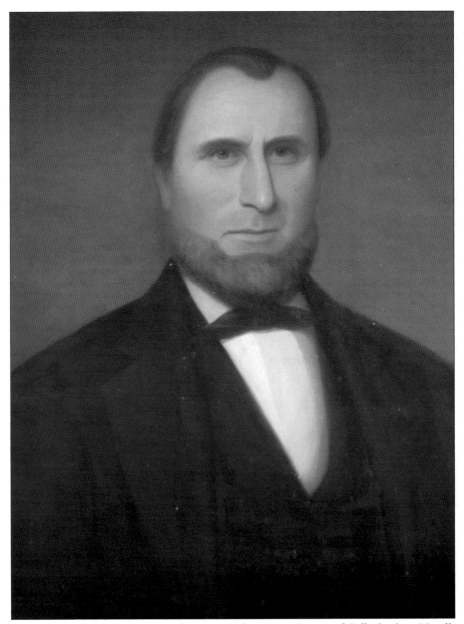

Watson Y. Hopkins was co-owner and master of the 37-ton *Peggy and Polly*, built at Vinalhaven in 1824. With his father, Theophilus Hopkins, he owned a 37-ton schooner, *Caroline*, built at North Fox Island (North Haven) in 1818. He owned *Lafayette*, a 27-ton schooner built at Essex, Massachusetts, in 1828 and a quarter share of *John Bell*, a 56-ton schooner built at Woolwich in 1847 and lost off Prince Edward Island. The crew of *John Bell* were rescued, including the master, Watson's son, Winslow R. Hopkins, later lost on the *Northern Chief*. In 1860, Watson Y. Hopkins reported in the industrial census that he had $2,500 capital invested in seasonal cod fishing, along with assets of 150 hogsheads of salt, 200 bushel barrels, $325 in a vessel, and $125 in sails. He had 12 employees who produced six hundred quintals of codfish valued at $1,800, one hundred bushel barrels of mackerel valued at $1,000, twenty bushel barrels of oil valued at $300, and thirty barrels of other fish valued at $150. He also had a farm.

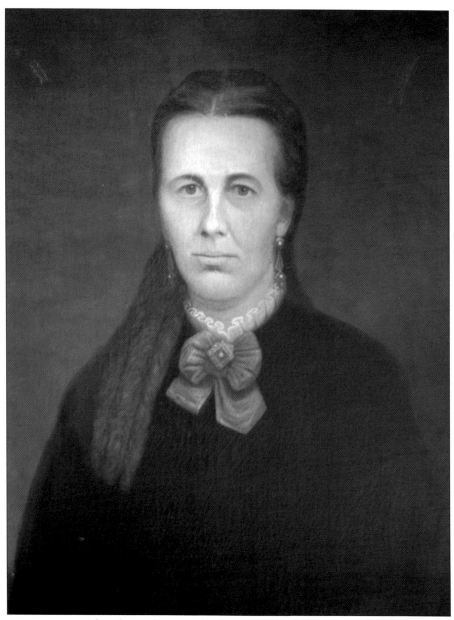

Not everyone returned to those who waited at home. In May 1865, Abigail Smith Ryder Hopkins lost her son, Capt. Winslow R. Hopkins, in a tragic accident at sea that claimed the lives of five other Vinalhaven men: John Lindsey, James Colby, Peter Walsh, William Parkhurst, and John Kent. The fishing schooner *Northern Chief*, commanded by Captain Hopkins, sailed with a crew of 11 from Green Island Cove and endured several days of bad weather, which may have led to seasickness and loss of vigilance on the watch. Shortly after midnight on the night of May 31, east of the shoal on Brown's Bank, the steamer *Bosphorus*, bound from Queenstown to Boston, bore down on the *Northern Chief* and struck it amidships on the port side. Abigail Smith Ryder Hopkins lost the son she had named in memory of her first husband, Winslow Ryder, who died before their third anniversary. Another woman, Mary Lindsey Hopkins, lost both her husband and brother.

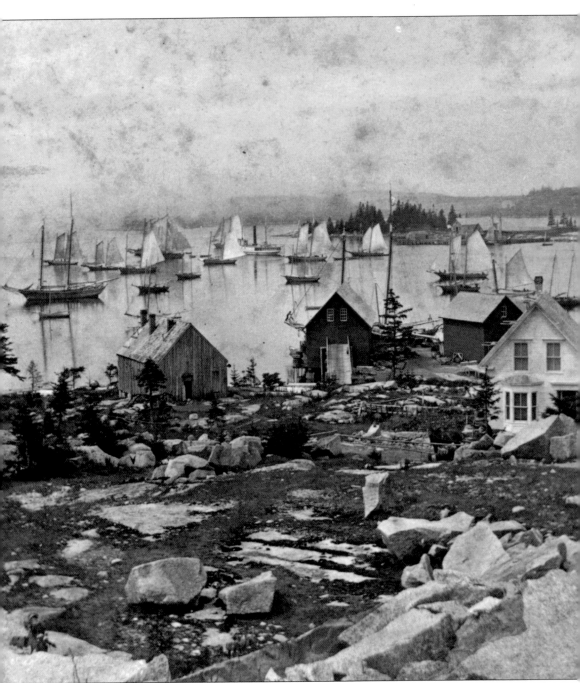

The village of Vinalhaven included many modest houses clustered near the shorefront, inhabited by the fishermen and their families. Vessel owners were not the only beneficiaries of the federal vessel bounties paid by collectors of customs districts. The vessel bounty was paid annually on the last day of December and divided between the owner and employees. A three-eighths share went to the owner and five-eighths went to the fishermen, prorated on their share of the catch. In the year 1860 alone, the Vinalhaven fleet caught 58,800,000 pounds of codfish in a season that lasted about six months.

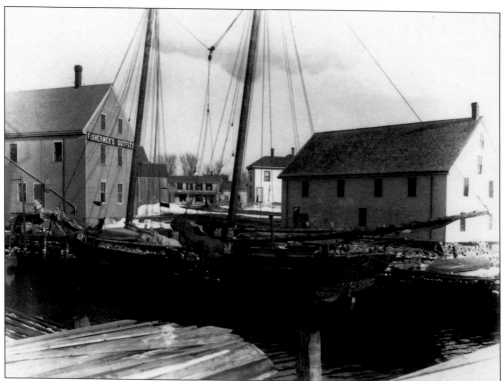

Polly was the name of several schooners that were registered as vessels whose home port was Vinalhaven. Schooners were useful for transport as well as fishing. It is possible that this is the same boat that Thaddeus Carver hired in 1775 to take the broken mill crank to the mainland.

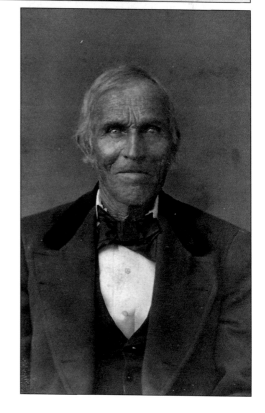

William Roberts was born September 18, 1831, married Lucy Tolman on September 12, 1853, and died on October 9, 1904. He was master and owner of *Ranger* and *Success*. He was also owner of one of the vessels named *Polly* as well as *Mur*, *Criterion*, and *Washington*.

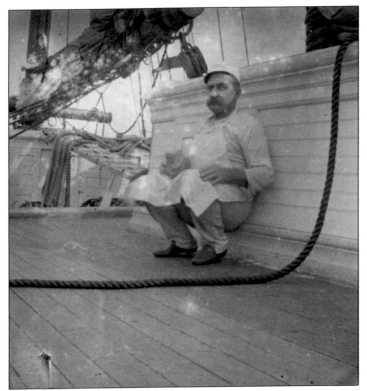

This ship's cook is sitting on the empty deck of a fishing vessel holding a cat. Fortunes in offshore fishing changed abruptly at the end of the Civil War, when the Tariff Act of 1866 repealed the federal fishery and vessel bounties. For a while, many believed the end had come for the once-prosperous fishery. The harbor fell quiet, and stray cats roamed the empty docks and fish houses. Some fishermen left the area or sought work in the seven granite quarries on the island, which employed 257 workers in 1870, according to the US Census.

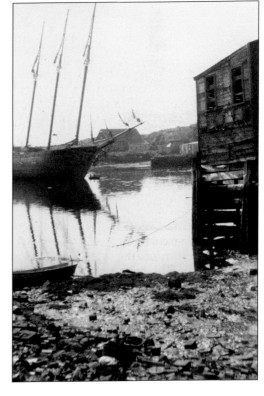

The size of this large schooner anchored near Clam Shell Alley can be gauged by comparison with the rowboat lying just off its bow. With the end of the federal bounties, some schooners built for offshore fishing became coasters, which transported goods along the eastern seaboard.

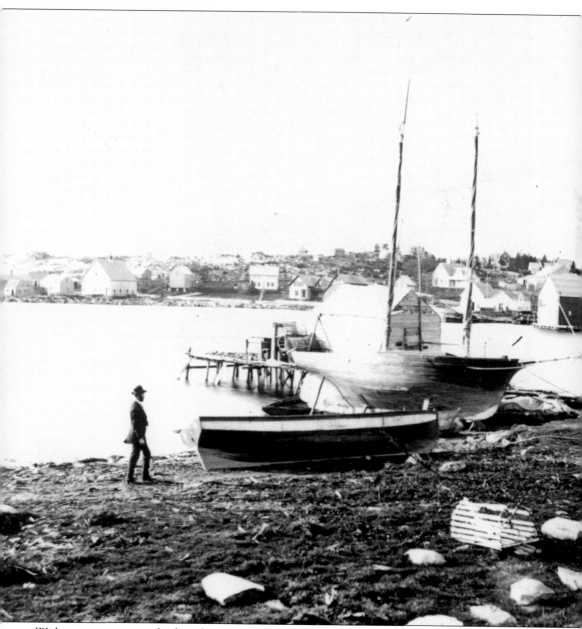

Without government subsidies, the income potential of offshore fishing was significantly reduced, while the risk remained the same. Some owners sold their boats quickly. Many schooners lay idle or were scuttled. This image is looking west across Carver's Harbor from a beach. Note the tender that was used to row to larger vessels.

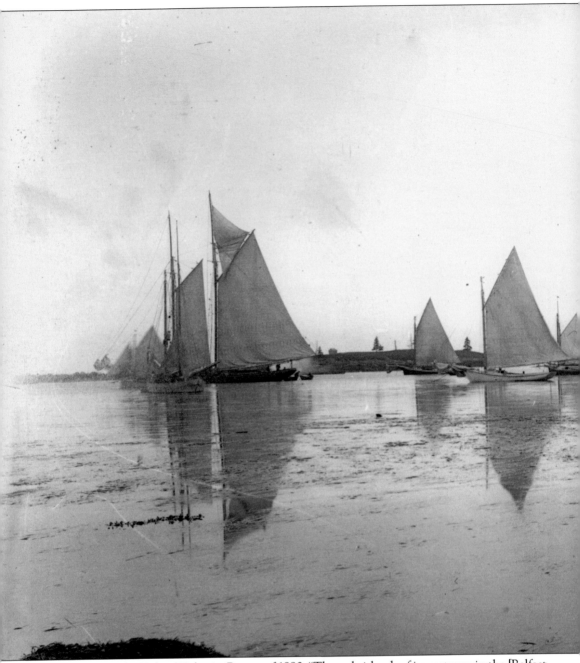

According to the Federal Fisheries Report of 1880, "The only islands of importance in the [Belfast Customs Region] group known as the Fox Islands are North Haven and Vinal Haven. These were settled about 1765 by parties from other localities, who came to Vinal Haven for the more

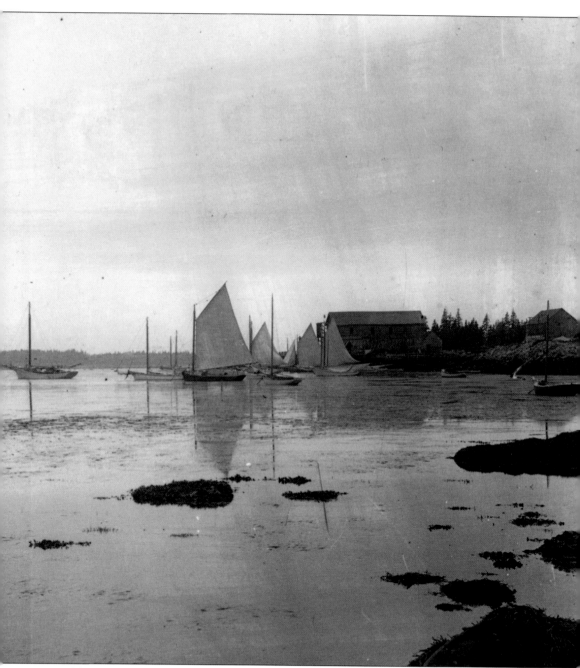

successful prosecution of the fisheries. Up to 1830 the vessels owned in this locality were small craft, most of them being under 30 tons, carpenter's measurement."

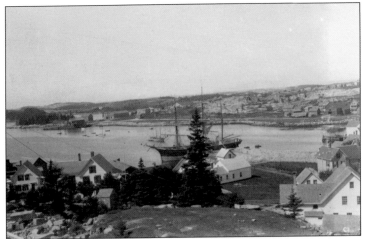

For decades after the end of the federal bounties, large vessels like this three-masted bark continued to bring salt and other supplies to Vinalhaven. Pictured here around 1900, the bark is anchored at the end of what is now known as Leo's Lane. In the background are quarries excavated by Bodwell Granite Company.

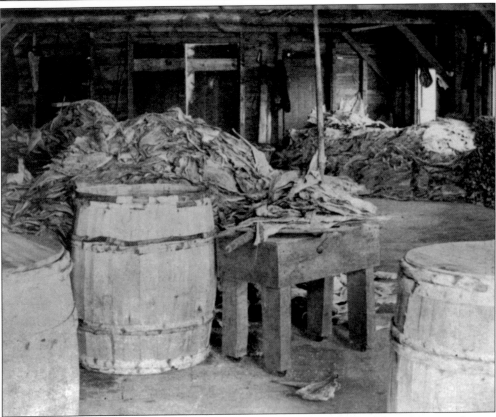

With the sudden end of federal fishery and vessel bounties, there must have been fewer warehouses filled with barrels of cured fish waiting for shipment to distant ports. The 1870 industrial census does not list any fishing vessels engaged in commercial fishing at Vinalhaven, though it enumerates three fish yards owned by George Hopkins, John Leadbetter, and Elisha Smith, which reported drying a total of 3,000 quintals (one quintal equals 100 pounds) of fish, a miniscule fraction of the fleet's catch a decade earlier and comparable to the annual catch for about three vessels. In 1870, R.L. Boman's Sail Loft only generated $332 for sail making and repairs, compared to revenues of $6,600 a decade earlier.

Two

THE ONSHORE FISHERY

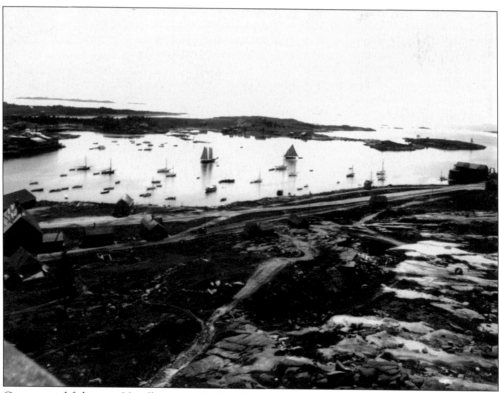

Commercial fishing at Vinalhaven revived with private investment in industrial fish processing. This glass-plate image, taken from Harbor Hill around 1900, shows some of the fishing fleet, with Lane and Libby fish plant (upper left), current Hopkins Boatyard (left foreground), and Steamboat Wharf (right).

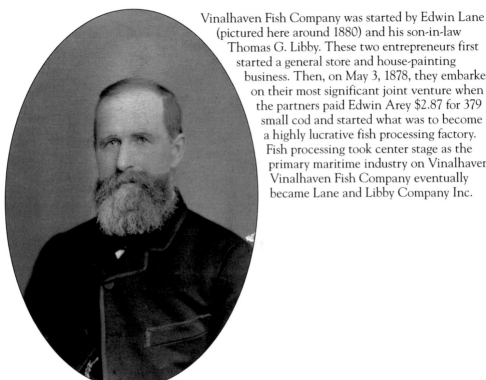

Vinalhaven Fish Company was started by Edwin Lane (pictured here around 1880) and his son-in-law Thomas G. Libby. These two entrepreneurs first started a general store and house-painting business. Then, on May 3, 1878, they embarked on their most significant joint venture when the partners paid Edwin Arey $2.87 for 379 small cod and started what was to become a highly lucrative fish processing factory. Fish processing took center stage as the primary maritime industry on Vinalhaven. Vinalhaven Fish Company eventually became Lane and Libby Company Inc.

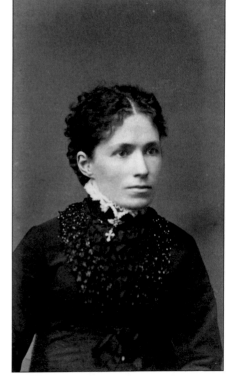

Compared to many other women on Vinalhaven, Margaret Lane Libby lived a life of relative privilege as the daughter of Edwin Lane and wife of Thomas Gardner Libby, cofounders of Lane and Libby. Born on November 14, 1850, and married January 1, 1869, she lived a long life and died on July 30, 1932.

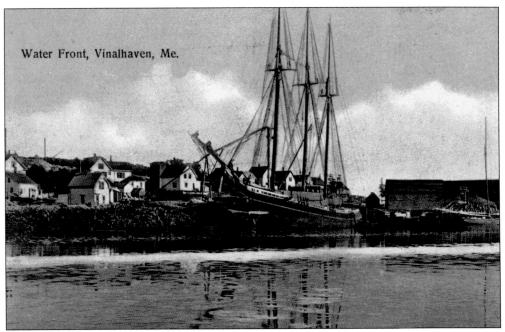

Water Front, Vinalhaven, Me.

This Italian schooner brought salt to the fish plant. Many tons of salt were used in the fish curing industry, and most of the salt was imported from the Mediterranean. In 1904, Lane and Libby's fish plant was using so much salt that the company erected a salt warehouse with a storage capacity of 3,000 hogsheads.

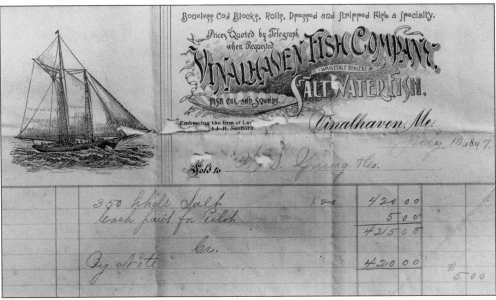

Vinalhaven Fish Company's invoice from July 10, 1897, described the company as "wholesale dealers in salt water fish" and said its products included fish oil, sounds, boneless cod blocks, rolls dressed, and stripped fish. Sounds are fish air bladders, considered a delicacy in Victorian times. This invoice documented the company's sale of 350 hogsheads of salt and pilot freight charges for $450. (Courtesy of Roger W. Young.)

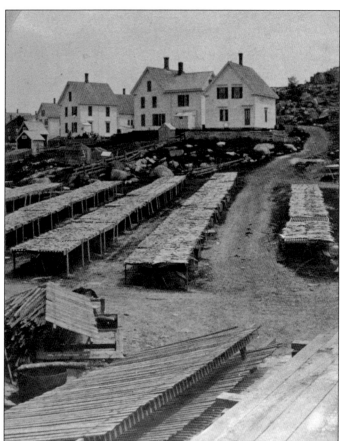

Flakes in the Lane and Libby fish plant yard were covered with hundreds of split and salted fish, drying in the sun. The neighborhood of houses on Atlantic Avenue had a distinct and memorable aroma during the curing season.

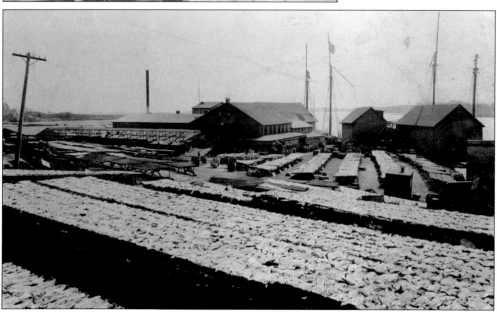

Flakes of salted cod fillets at Lane and Libby fish plant dry in the sun, and the schooner *Ida Libby* is moored at the dock, according to a note on this image.

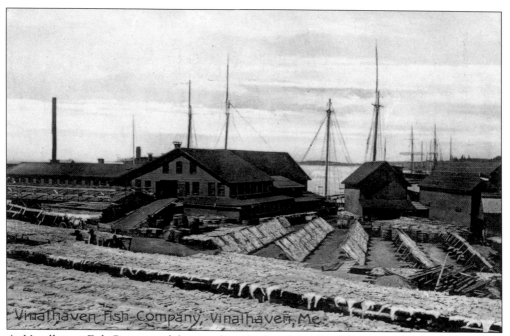

At Vinalhaven Fish Company, fish was split, salted, and dried in full sun in a fish yard on wooden racks called flakes. The only overhead required to start a fish yard was a bit of sunny open land and some lumber.

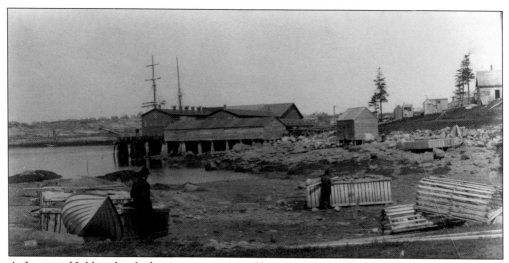

At Lane and Libby wharf, a brigantine is pictured here in a photograph taken from Fred Greelaw's Cove around 1900. Schooners tied up at the fish plant wharf to unload the catch for processing as well as load cured fish for transport to market. A very low tide made it difficult to load and unload boats at the wharf but made it easier to repair a lobster float (foreground).

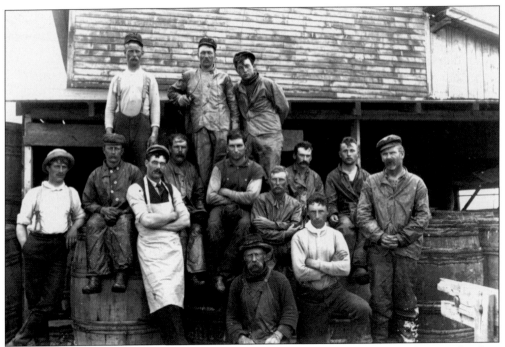

Capt. Lew Smith's fish crew at Lane and Libby are captured in this glass-plate photograph taken around 1900, likely by a photographer hired by the company.

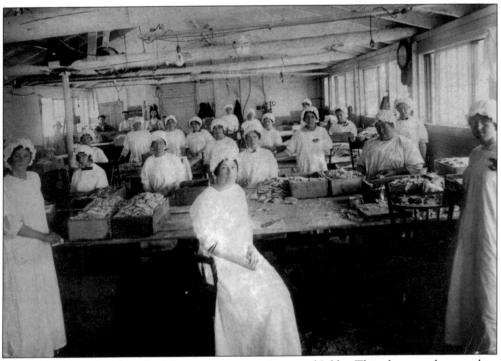

Women were employed in the fish cutting room at Lane and Libby. This photograph was taken during the 1890s.

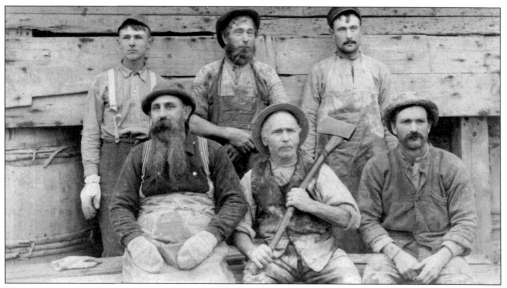

These men were fish cutters at Lane and Libby fish plant during the early 1890s. From left to right are (first row) Rufus Coombs, James Smith, and Seth Sholes; (second row) Lyford Pierce, George Jackson, and Walter Smith. A skilled fish cutter could split many hundreds of pounds of fish in a day.

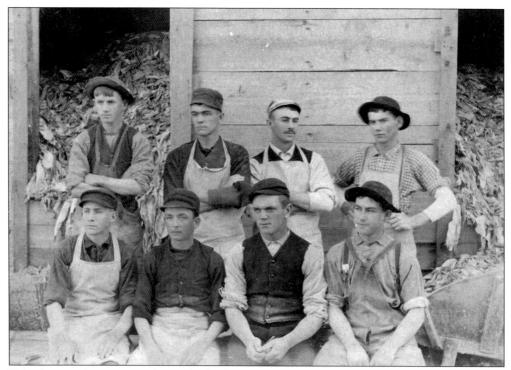

Fish plant workers pose in front of a shed. Lane and Libby had the largest fish curing plant in the state and one of the largest in the country. By 1903, during the fishing season, the company employed on average 100 workers in the factory and another 200 workers in boats.

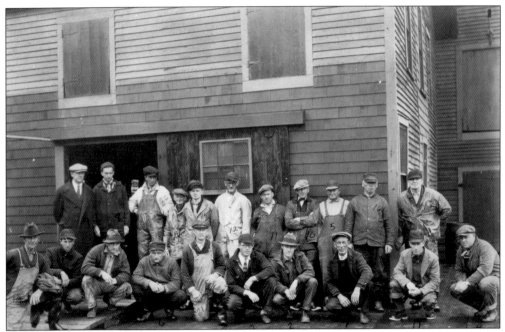

These workers were employed by Lane and Libby fish plant in the 1930s. From left to right are (first row) H. Green, Maynard "Chicken" Smith, Bill Chilles, Harvey Tolman, Capt. Lew Smith, Everett Libby, Les Dyer, Hanse Brown, Ed Smith, and John H. Morton; (second row) Benny Smith, Ernest Tolman, unidentified, Joe Ames, Milton Ames, Earl "Bruiser" Lawry, Max Conway, Langtry Smith, Fred Clayter, Ben Dyer, and Crowell Hatch. (Courtesy of Vinalhaven Eldercare Services.)

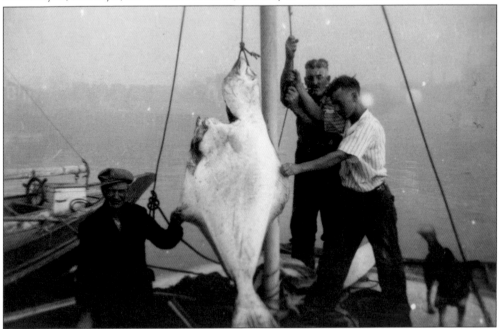

The Vinalhaven fleet landed some impressively large fish. Owen Dyer (right) caught this large halibut he unloaded at the dock with help from John "Reddy" Phillip (center) and Elmer "Bangor" Martinson.

In the fish plant, the woman on the right is candling filleted fish on a light board to see and remove worms. The man on the left is weighing and packing the fillets.

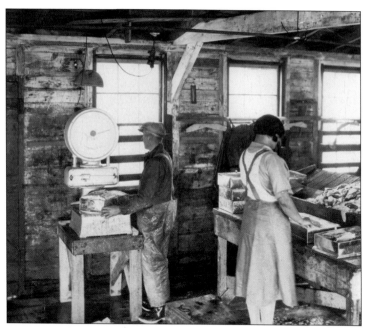

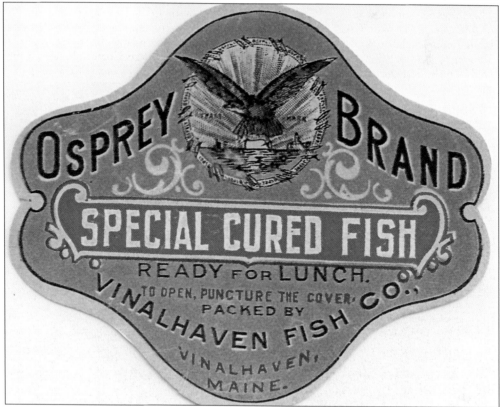

OSPREY BRAND

SPECIAL CURED FISH

READY FOR LUNCH.

TO OPEN, PUNCTURE THE COVER.

PACKED BY

VINALHAVEN FISH CO.,

VINALHAVEN, MAINE.

Osprey was one of Vinalhaven Fish Company's brands, shown in this commercial label. The company bought fish from independent vessels and their own fleet and preserved it by drying, smoking, or pickling and packed their own boxes, barrels, and drums branded "Osprey, the World's Best."

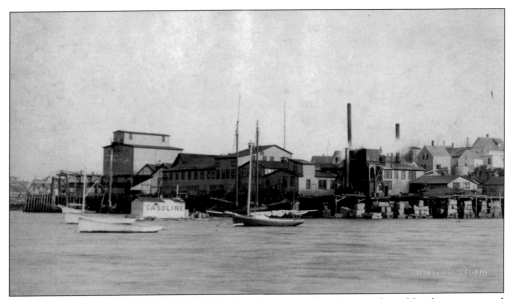

Lane and Libby's wharf was a busy place, with schooners offloading catch and loading processed fish destined for distant markets. The wharf was 400 feet long, allowing multiple vessels to tie up at one time. The fishing industry is weather dependent, and the same conditions affected all boats, so there were busy days when some boats would have to wait in the harbor for their turn at the fish plant wharf.

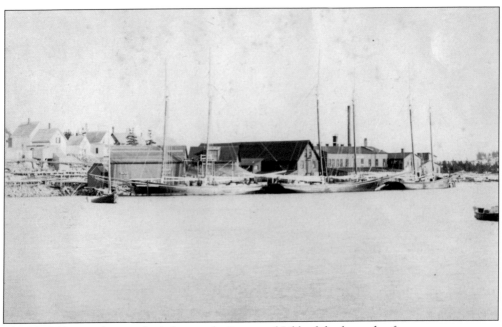

The *Ida Libby* was frequently tied up at the Lane and Libby fish plant wharf.

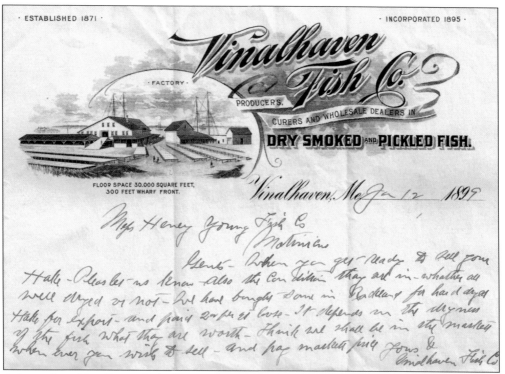

A letter from Vinalhaven Fish Company to Henry Young Fish Co. of Matinicus said on June 12, 1899: "When you get ready to sell your hake, please let us know. Also the condition they are in—whether all dried or not . . . It depends on the dryness of the fish what they are worth . . . Think we shall be in the market whenever you wish to sell—and pay market price." (Courtesy of Roger W. Young.)

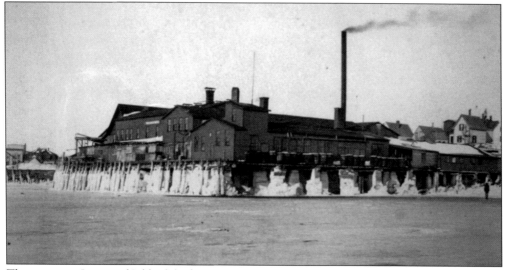

The two-story Lane and Libby fish plant was constructed with 85,000 square feet of working space for processing various species of fish. When winter passed and the mackerel returned to Penobscot Bay, some fishermen, farmers, and quarrymen abandoned other pursuits for a few weeks to fish for mackerel, then returned to fishing for cod, hake, and haddock or returned to the quarries.

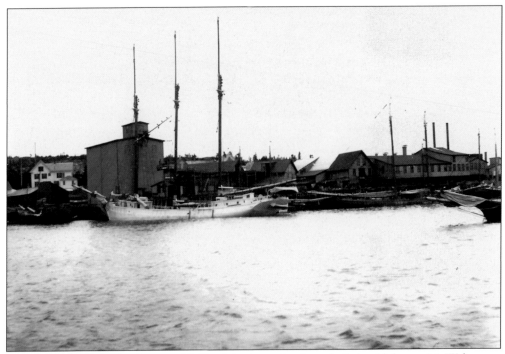

The *Margaret M. Ford* at Lane and Libby fish plant wharf was built by Alphonso M. Webster at Pleasant River in 1903. This vessel carried a crew of up to seven men and was the largest boat ever built at Vinalhaven: 132.5 feet long and 291 net tons with a 34.5-foot beam. In 1917, she was stranded on Eleuthra Island in the Bahamas.

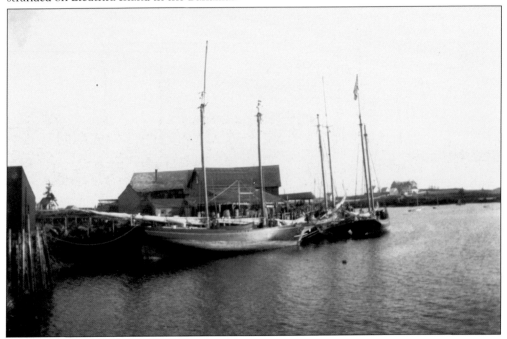

These schooners are tied up at Lane and Libby's wharf in the late 19th century. In the background is Lane's Island.

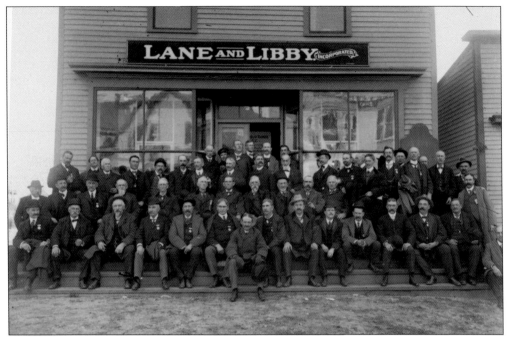

This image of Lane and Libby's general store shows an unknown fraternal organization (wearing badges), seated in front. The general store was the first joint venture of Edwin Lane and Thomas G. Libby, who later started Vinalhaven Fish Company.

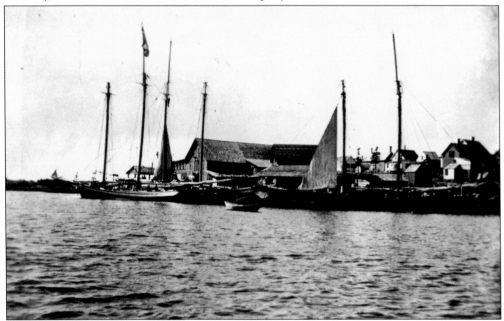

The Lane and Libby fish plant is pictured here, looking towards town. In 1903, a subsidiary corporation, Vinalhaven Glue Company, began manufacturing glue, fertilizer, common oil, and medicinal cod liver oil from by-products of the parent company in a brand new 30-by-75-foot factory equipped with modern machinery. The factory featured an artesian well 225 feet deep with a 10,000-gallon holding tank, as the new factory demanded 5,000 to 10,000 gallons of water daily.

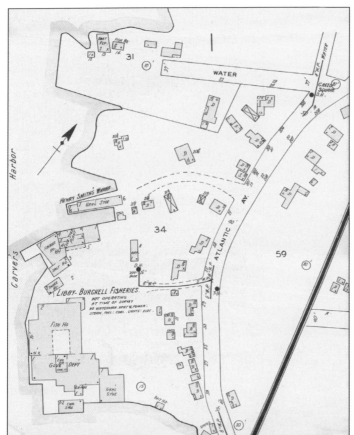

The location of fish plant buildings between Atlantic Avenue and Carver's Harbor is shown in this Sanborn Insurance Company map. Along the harbor were the wharf, freight house, and cold storage plant with the salt house, smokehouse, glue department, and fish house plant behind. By the time this map was published in 1933, Lane and Libby had become Libby Burchell.

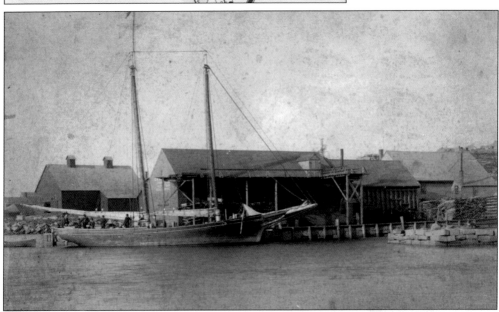

The schooner *Harvester* is moored at the Lane and Libby dock. This boat was a familiar sight in Carver's Harbor.

Pictured here is Capt. Elisha "Lish" Roberts, born at the height of the fishing boom in 1852. He married Adelaide Turner on May 3, 1882. Captain Roberts was owner and master of the *Harvester* and *Pavilion*. He also had a sizeable farm at Roberts' Harbor. He died on January 13, 1931.

A three-masted bark loads fish at the Lane and Libby dock prior to 1909, when the cold storage was added.

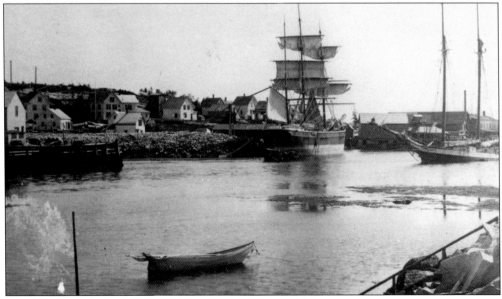

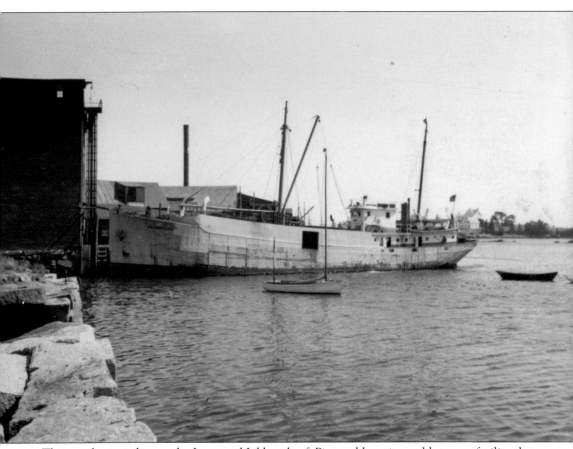

This trawler is tied up at the Lane and Libby wharf. Pictured here is a cold-storage facility that was installed in 1909. Despite investment in the new technology for freezing fish, the company did not continue to keep pace with changes in market demand. In 1929, on the eve of the Great Depression, the company needed funding from outside investors, who changed the name to Libby Burchell. Later, the company was sold to General Sea Foods Corporation, which operated the factory intermittently before deeming it obsolete. The fish plant was razed in 1940.

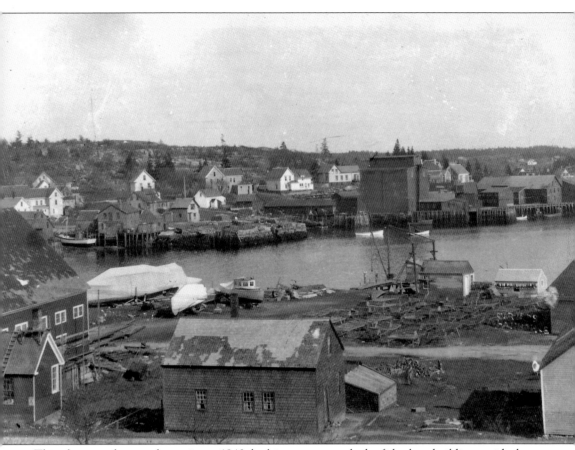

This photograph was taken prior to 1940, looking east towards the fish plant buildings, with the boat yard in the foreground. Based on the lack of fishing boats at the fish plant wharf, the plant was probably not in operation at the time.

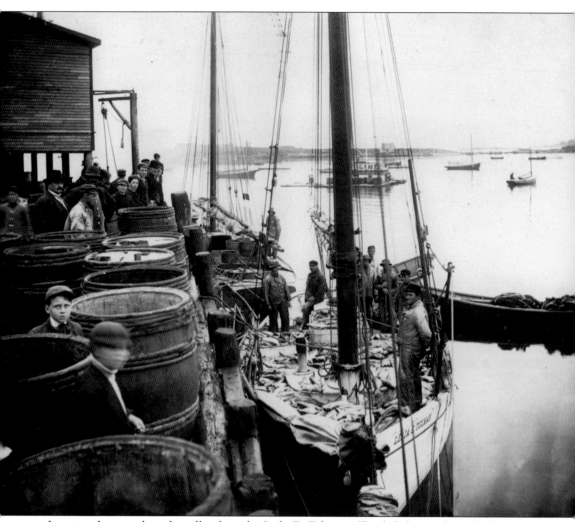

Imagine the sounds and smells when the *Leila E. Tolman* offloaded the catch at the busy Lane and Libby dock. (Courtesy of Maine Historic Preservation Commission.)

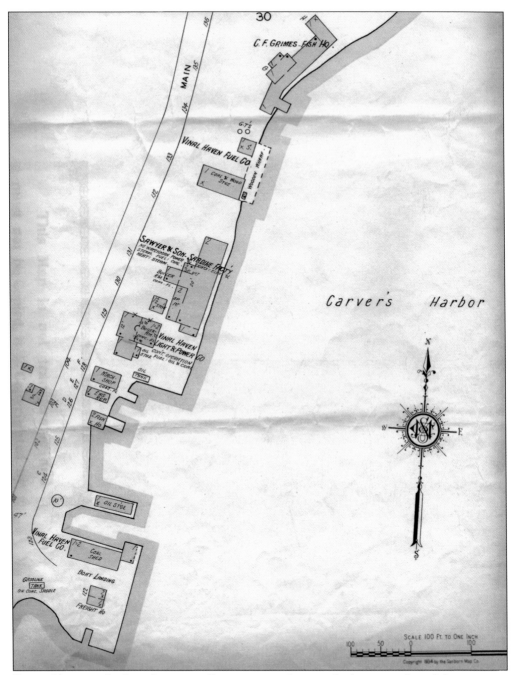

Pictured here is a Sanborn Insurance Company map showing the location of two fish processing plants, Sawyer's sardine factory and C.G. Grimes, on what is today West Main Street.

Sawyer's sardine factory opened in 1917 and ran intermittently for a decade. Sardines are small oily fish of several species related to herring. They travel in schools in coastal waters, where they are caught in encircling nets, particularly purse seines. Sardines are processed by canning.

The *Adrienne* is tied up at Sawyer's sardine factory, where the catch was offloaded and processed.

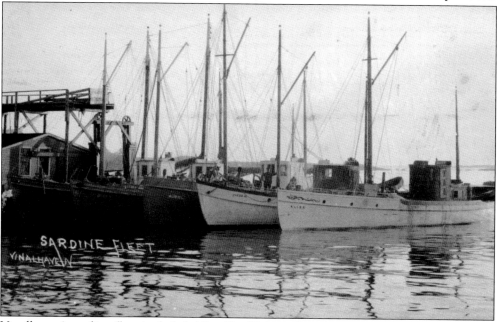

Vinalhaven's sardine fleet included *Alice, Eva H, Muriel,* and two other vessels. (Courtesy of Maine Historic Preservation Commission.)

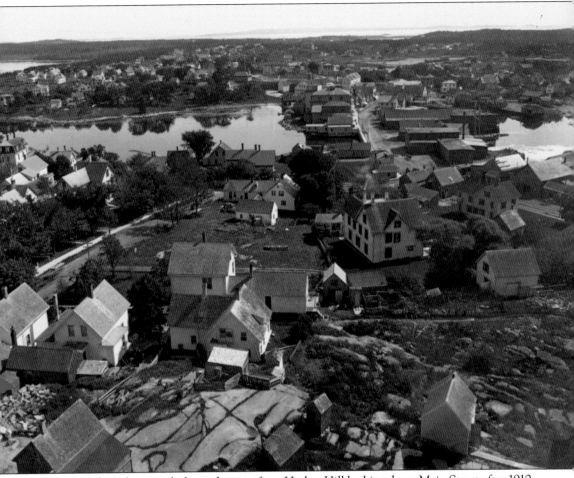

This glass-plate photograph shows the view from Harbor Hill looking down Main Street after 1910. At that time, the island's economy was based on two industries that harvested natural resources: quarrying and fishing. Thin topsoil and bedrock cover much of the island, which limited the role of farming in Vinalhaven's economy.

Three

TO FARAWAY MARKETS

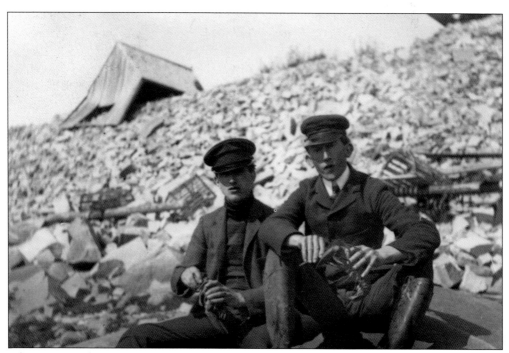

John Lowe and Babbin Fifield, Bodwell Granite Company employees, hold lobsters up for photographer W.H. Merrithew around 1900. The men are sitting on a pile of grout, a by-product of quarrying that was used as landfill along the waterfront. Half a century after this photograph was taken, lobsters were still easily collected close to the water's edge. The onshore fishery includes fish trapped or taken in nets from shallow waters alongshore.

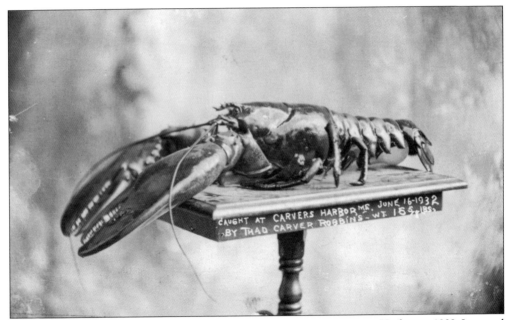

This lobster, which weighed more than 15 pounds, was caught at Carver's Harbor in 1932. Leonard "Buddy" Skoog told the author that "at low tide, we would get lobsters, particularly at shedder season, take a gaff and walk up and take 'em, back in the early 40s. Down there in Indian Creek we would get a bushel basket of flounders. The tide brought them in. But it's all different now."

Waiting for the season to begin, lobster traps (pots) were stacked high by Dyer's fish house in the early 1960s on today's Mary Wentworth Road, off Atlantic Avenue.

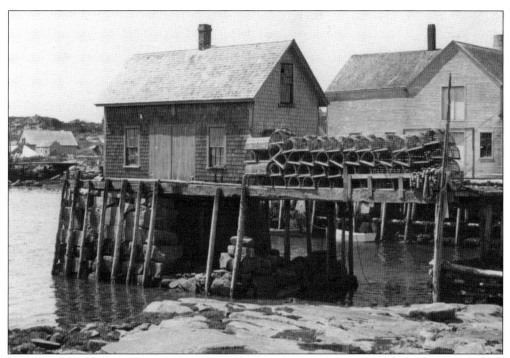

The lobster pots by this fish house were probably manufactured by hand by a fisherman. Lobster pots were constructed in the fish houses during winter or days when it was unsafe to venture outside the harbor.

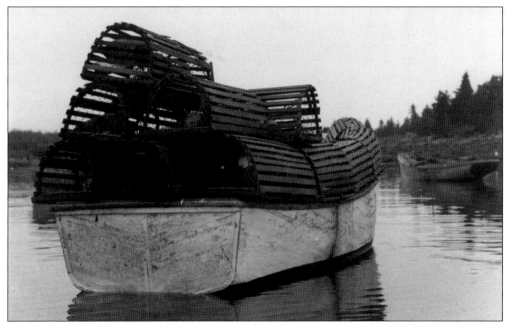

Wooden lobster traps like the ones on this punt were often made of spruce. They had a flat bottom and a rounded top. There was a door that opened for baiting the pot with herring or mackerel, secured on an iron stake or in a knitted bait bag. A brick or stone was used to sink the pot in the water.

In 1884, Messrs. Johnson & Young of Boston constructed the island's first lobster pound at the Basin. It had a capacity of 150,000 pounds of lobster. Lobster pounds were an innovation that increased profits for lobster wholesalers. They bought soft-shelled lobsters from fishermen in warm months when their shells were undesirably soft, supply was abundant, and prices low. They held the lobsters in pounds while the shells hardened. Then, they shipped and sold the lobsters to retailers in the holiday season, when demand and prices peaked.

Lobsterman Ralph Clayter and his wife, Winnifred, are pictured here in the early 20th century. Clayter and Willie Burns (page 121) occupied adjacent fish houses on T Dock. Both used the colors red and white on their lobster pot buoys, but in opposite locations.

54

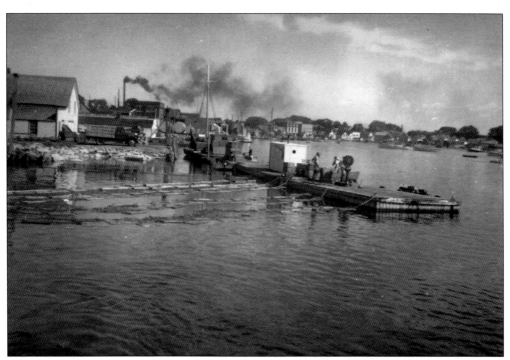

Clyde L. Bickford's lobster car held floating crates filled with live lobsters, ready for shipment. This image dates from the mid-20th century. The scale on the dock was for weighing the lobster for sale.

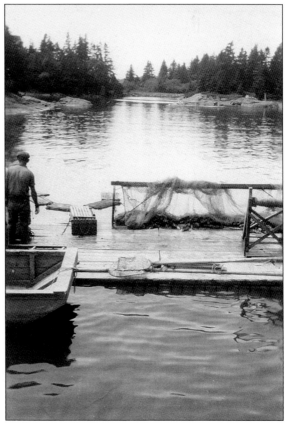

This photograph was taken in 1945 and shows the process of dragging the lobster pound to remove lobsters for shipping to market.

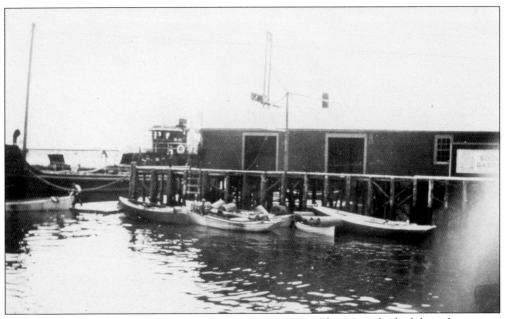

Plato Arey had a lobster buying station and wharf, pictured here.

A note on this mid-1940s snapshot says, "Ida, Nora and Mae plugging on the car." Before lobsters were placed in close quarters in a crate for shipping, wooden plugs were placed in their claw joints to prevent them injuring each other. This reduced mortality during transport.

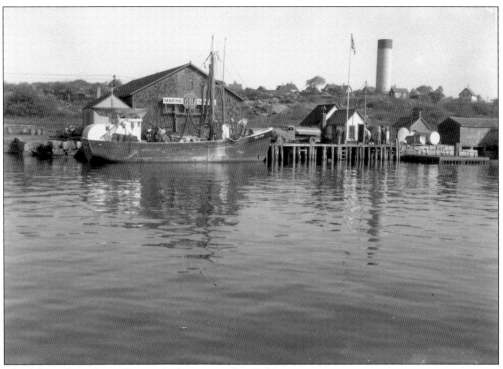

The lobster boat *Dora Peter* is fueling up at the Gulf marine station.

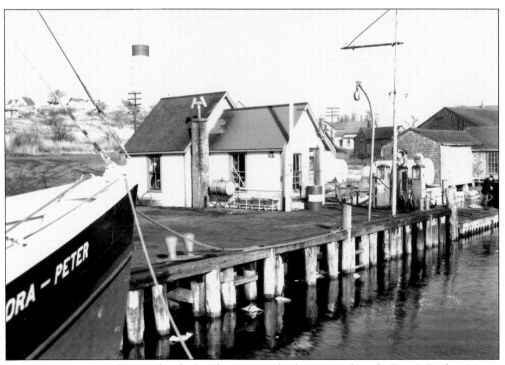

The *Dora Peter* is tied up at the dock. This is now the location of Linda Bean's Perfect Maine buying station.

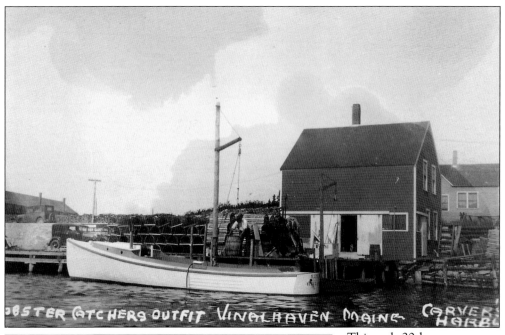

This early-20th-century postcard for the tourist market depicts a lobster catcher's outfit.

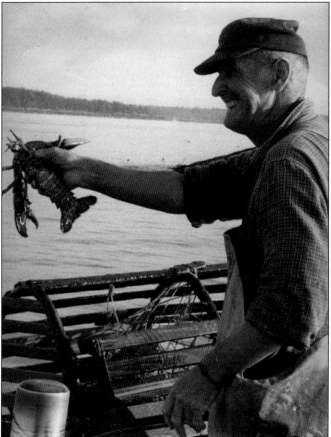

Lobsterman Harry Young is removing a live lobster from a pot. This one may be too small to keep.

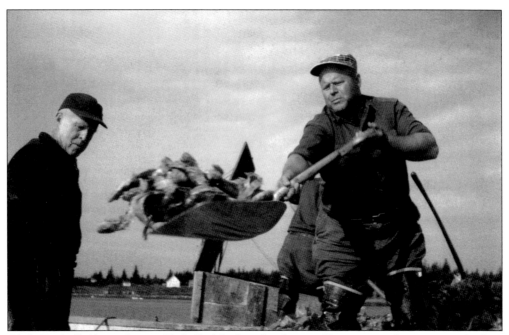

Clyde Poole (left) watches as Clyde Bickford pitches bream. Herring was the most popular bait for lobstering, though other fish were used as well. Many of the tasks associated with lobstering, like pitching bait and stacking pots, require significant physical strength.

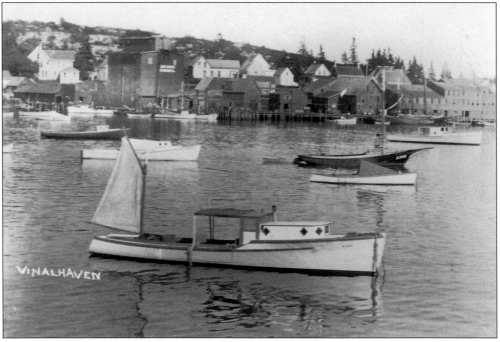

This lobster boat, seen near the fish plant, has both a jigger sail and motor. At the time this photograph was taken in the early 20th century, lobstermen added motors to their boats primarily as backups if the wind died down. There was some suspicion of engines, which were regarded as potentially dangerous. Many lobstermen purchased Knox engines from a local company on the mainland.

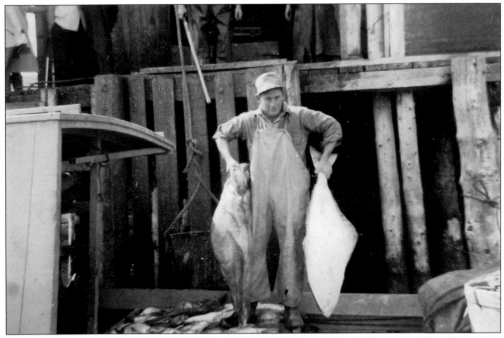

Lobsterman Bert Dyer caught the two halibut shown here. In his later years, Dyer was renowned for telling great fish stories.

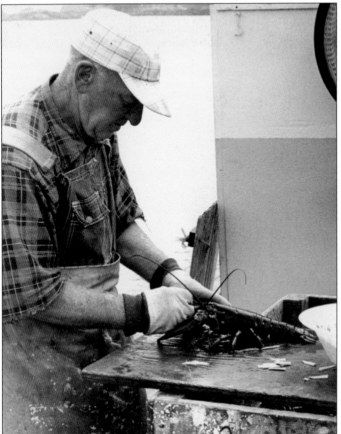

Lobsterman Frank "Honey" Small is shown here at C.L. Bickford Lobster Company, plugging a lobster's claw. Vinalhaven native Small was born in 1903. He accidentally drowned in 1962. (Courtesy of Dick Mathews.)

Lobsterman Ashley Genthner is shown using a gaff (long pole with a hook on the end) to reach his pot buoy in the late 1960s. The rope can then be pulled to haul the trap to the boat. Throughout the 19th and early 20th centuries, lobster pots were set and hauled by hand using a gaff, requiring significant strength. Lobstermen welcomed the introduction of the hydraulic winch. (Courtesy of Dick Mathews.)

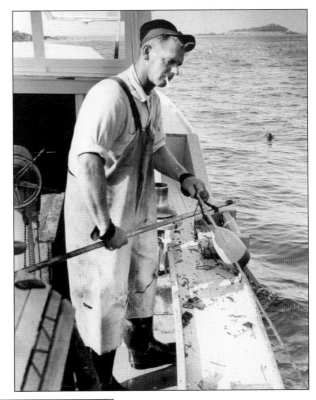

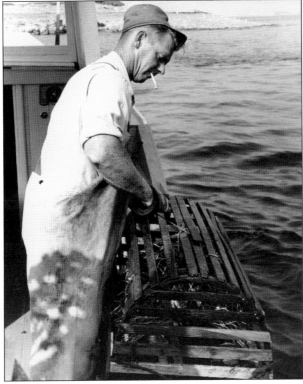

Lobsterman Ashley Genthner opens his lobster trap. In the late 20th century, design improvements increased efficiency: stacking more pots in less space with a flat-topped rectangular design and reducing weight by replacing wood with mass-produced wire mesh parts. (Courtesy of Dick Mathews.)

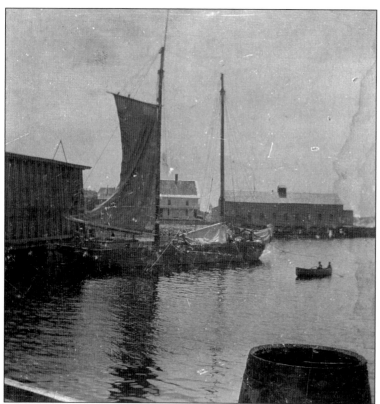

Schooners like this one were used for lobstering in shallow water during the late 19th and early 20th centuries. This boat is tied up at the wharf where lumber, wood, and coal were sold by Bodwell Granite Company, located at the current town parking lot on Main Street. Shippershins Wharf is in the background.

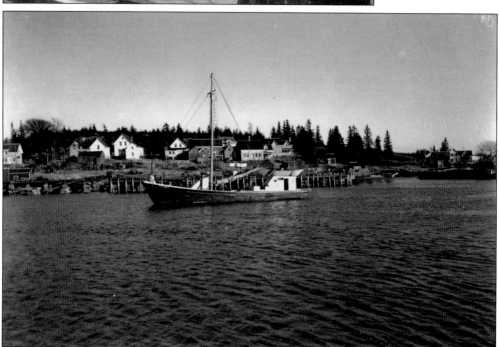

This photograph of a lobstering sloop was taken after the Lane and Libby fish plant was razed in 1940.

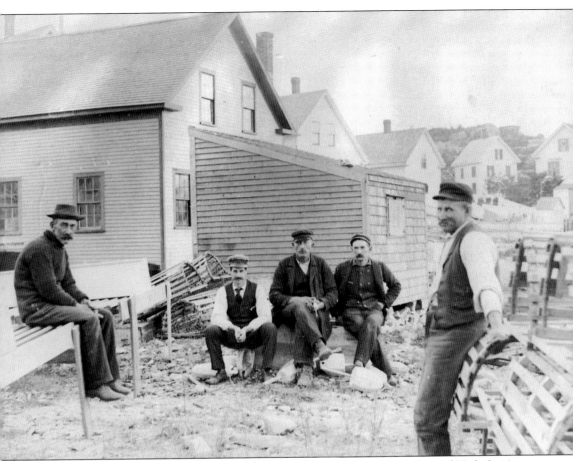

From left to right, Ed Beggs, Edward G. Carver, Bill Clayter, George Coombs, and Nicholas Arey take a break by Frank Osgood's boat shop on Clam Shell Alley. In fish houses and boat shops that ringed Carver's Harbor, old men seated on barrels, rough board benches, and maybe a discarded kitchen chair conducted the business of the town while mending nets, traps, and buoys. They missed nothing that happened in and around Carver's Harbor. And important news traveled fast, from fish house to fish house.

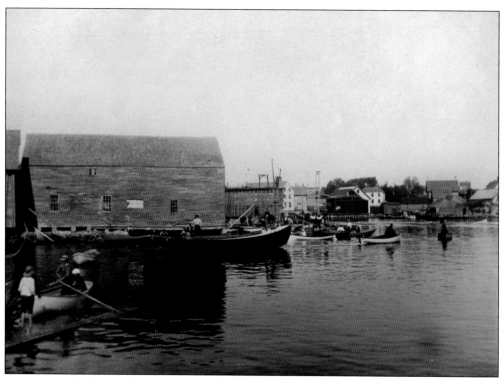

In Carver's Harbor, the boys in the rowboat (left) are watching a boat being launched from Truman Sawyer's boat shop (center).

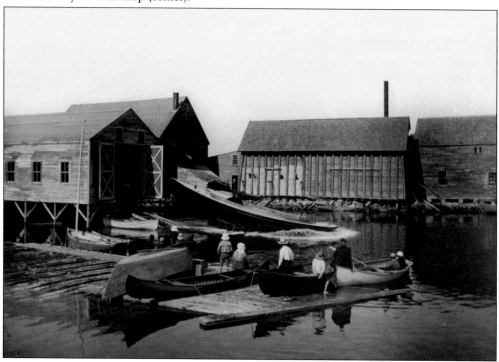

Pictured here is a boat launching at the boat shop of Truman Sawyer.

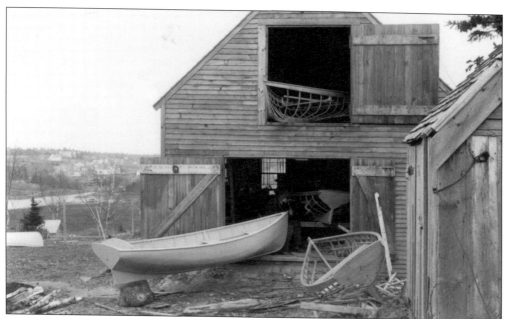

Fred Barker's boat shop was located on Old Harbor Road, and boats were towed to Creeds Cove to be launched. This glass-plate photograph was taken around 1900.

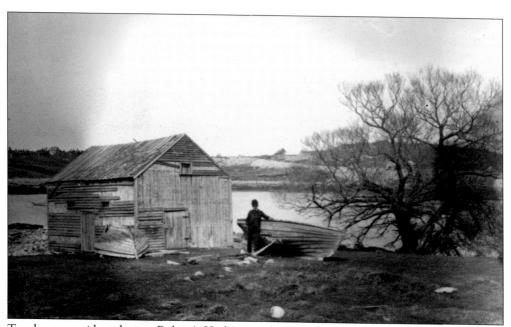

Two boats outside a shop at Robert's Harbor are shown in this glass-plate photograph, around 1900. The boat on the right has damaged planking on the hull.

Small boats were built around wooden molds, which were cherished and handed down in boatbuilding families. This peapod was built in Phil Dyer's boat shop using molds copied from those used by his father-in-law, Harold "Hokey" Gustafson. (Courtesy of Neal Brian Martin)

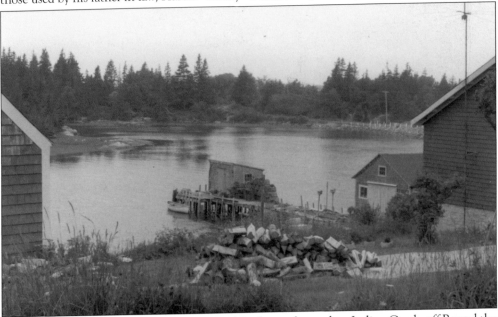

Boatbuilder Hokey Gustafson's fish house and dock were located on Indian Creek, off Round the Mountain Road. Gustafson introduced his son-in-law, Phil Dyer, to boatbuilding.

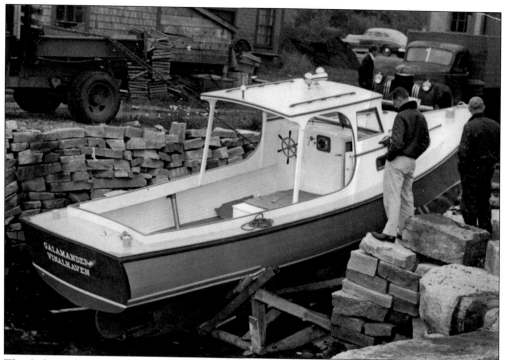

The *Galamander* was built by Gus Skoog. This photograph, taken in 1955, shows Leonard "Buddy" Skoog (left) and Gus Skoog at the launching. (Courtesy of Leonard Skoog.)

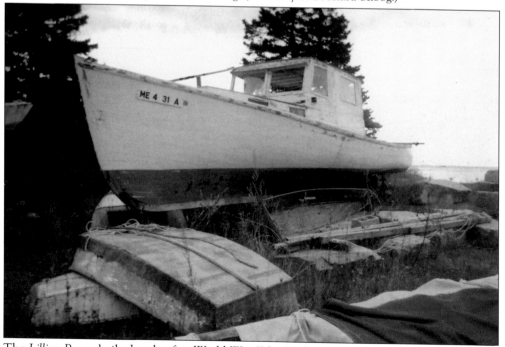

The *Lillian B* was built shortly after World War II by Fred Barker for Hugh Kenneth "Canary" Arey. She was later owned by Henry "Babe" Swears and the Reynolds family. (Courtesy of Roger W. Young.)

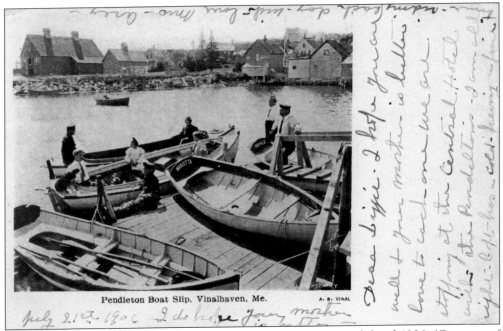

The Pendleton boat slip at Vinalhaven is pictured on this postcard dated 1906. (Courtesy of Delwyn C. Webster.)

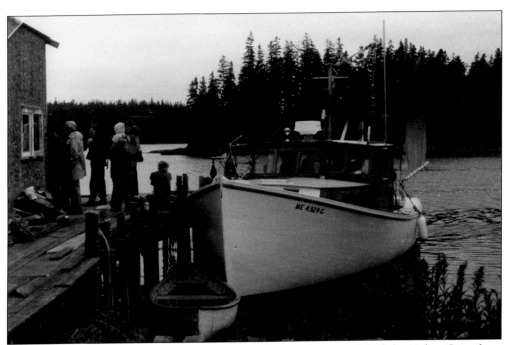

Pictured at Phil Dyer's boat shop are Ron Ames's boat and a peapod built by Hokey Gustafson. Ron Ames came to see Lou Romer's boat launched. (Courtesy of Charlotte Goodhue.)

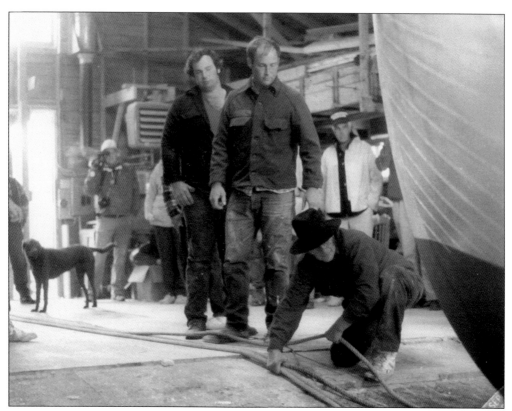

Jeff and Dave Moyer help Phil Dyer launch Lou Romer's boat on September 13, 1989. Bob Schriner is filming in the background. (Courtesy of Charlotte Goodhue.)

This peapod boat was built by Phil "Philo" Dyer at Vinalhaven in the late 20th century. (Courtesy of Neal B. Martin.)

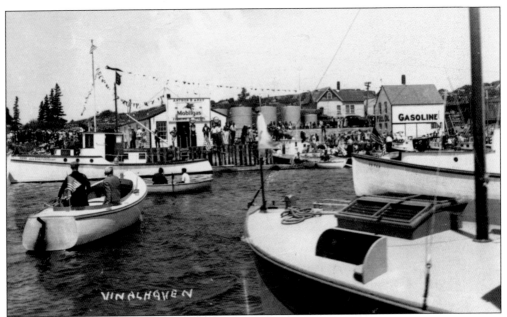

Vinalhaven's fishing fleet included boats of all sizes, all of which were on display on July 2, 1939, when the town of Vinalhaven celebrated its 150th birthday with a four-day extravaganza, including the marine parade depicted in this postcard.

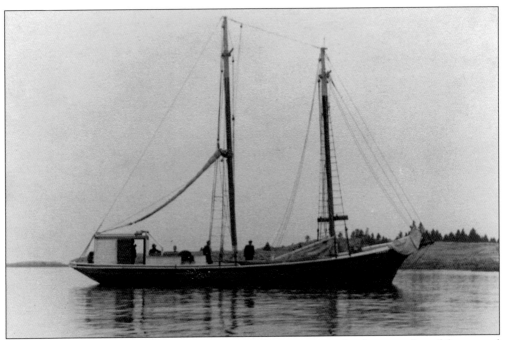

Verna G, owned by Ralph J. Bickford, was originally a two-masted sailing vessel used for ground fishing. In the 1940s, an engine was installed, and it carried crates of lobster to Portland and Boston. In the 1950s, *Verna G* sank while tied up at the wharf, but she was raised and taken to South Addison, Maine.

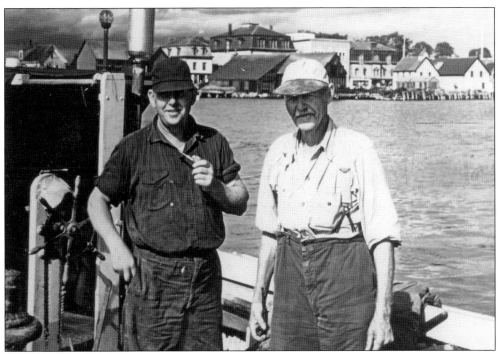

Fisherman Henry Llewellyn Thomas and his son-in-law Sigvard H. Melin pose at Carver's Harbor around 1955. (Courtesy of Roger W. Young.)

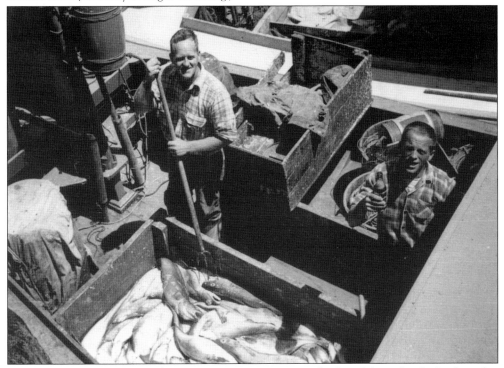

Alfred "Kippy" Greenlaw and Stuart "Hoss" Davis were unloading fish at the dock when this photograph was taken in the 1950s.

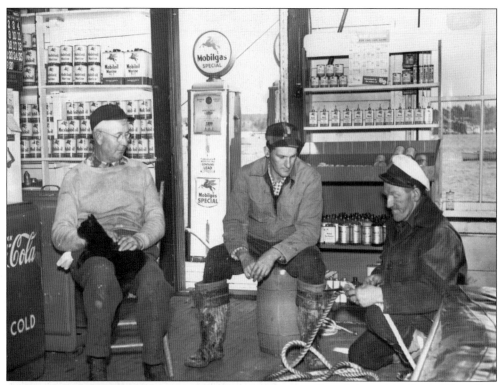

From left to right, Leon "Goose" Arey, Merrill T. Thompson, and John "Reddy" Phillip visit at A.B. Arey's store on the wharf.

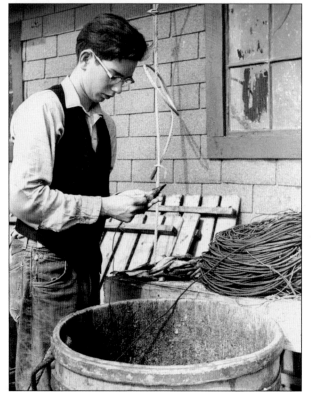

Peter Day is baiting trawl in this photograph taken in the mid-1960s. (Courtesy of Dick Mathews.)

When baiting trawls, hooks and bait were laid into barrels so they would not tangle or hook each other when the trawl unraveled as the lines were set out. Pictured here from left to right are Allan "Ike" Wallace, Margaret Warren, unidentified, Billy Warren, and Leland Warren.

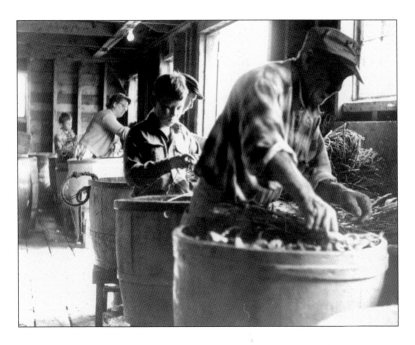

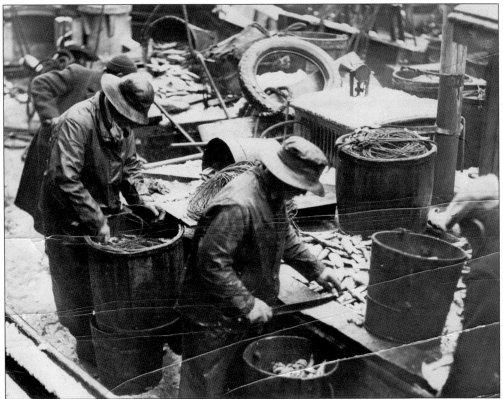

This image shows the process of baiting trawl. Prior to development of trawl lines, fishermen would use single hand lines with baited hooks to catch codfish, and jig lines to catch mackerel. A trawl line with hundreds of baited hooks significantly increased the size of the catch.

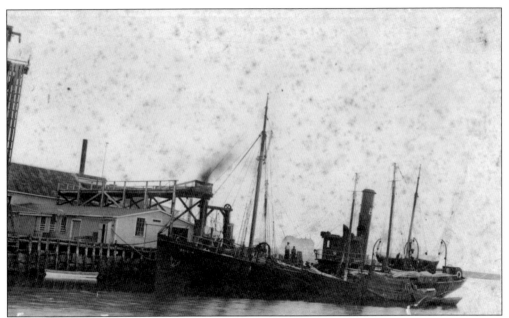

The first steam trawler arrived at Lane and Libby on October 3, 1919, as shown in this postcard image. In the late 19th century, several innovations improved the efficiency of offshore fishing. Cod and halibut were no longer caught on single lines but by trawl lines bearing hundreds of baited hooks, released from small dories sent out from a main vessel. Mackerel were no longer caught by single jig lines and gill nets; instead, entire schools of mackerel were taken at one time in drawstring purse nets.

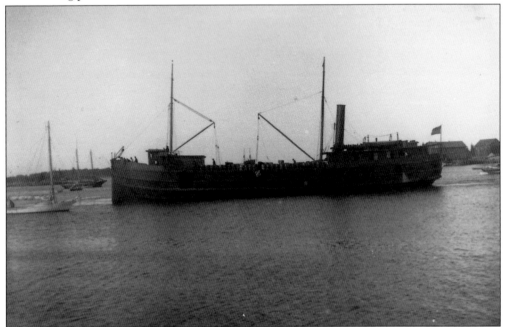

A trawler arrives in Carver's Harbor near Steamboat Wharf (in background). Trawling and purse seining required an initial investment of capital but significantly increased the catch. The fishing industry quickly adopted these innovations.

This sardine boat was photographed as it waited to take on a load.

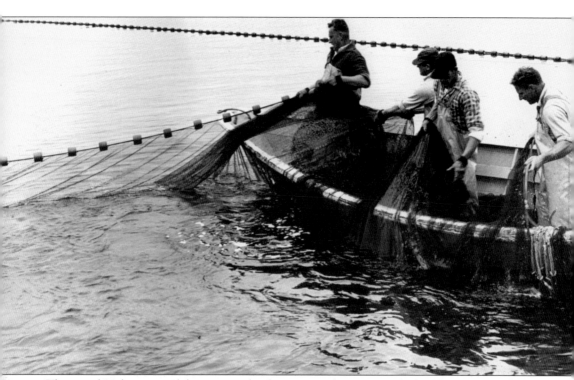

These mid-20th-century fishermen are hauling seining herring nets by hand. Herring include a number of related species of small, oily fish used both for bait and food. According to Thomas Beverage, herring was an important product at Vinalhaven as early as 1819. From left to right are Bruce Johnson, Herb Conway, Lyford "Dyke" Conary, and John Beckman. (Courtesy of Dick Mathews.)

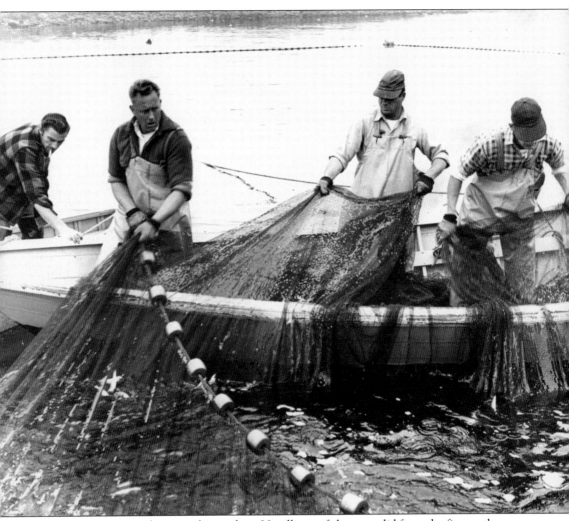

Hauling seining nets to bring in the catch, as Vinalhaven fishermen did from the first settlement until the late 20th century are, from left to right, Wallace Smith, Bruce Johnson, Herb Conway, and Lyford "Dyke" Conary. (Courtesy of Dick Mathews.)

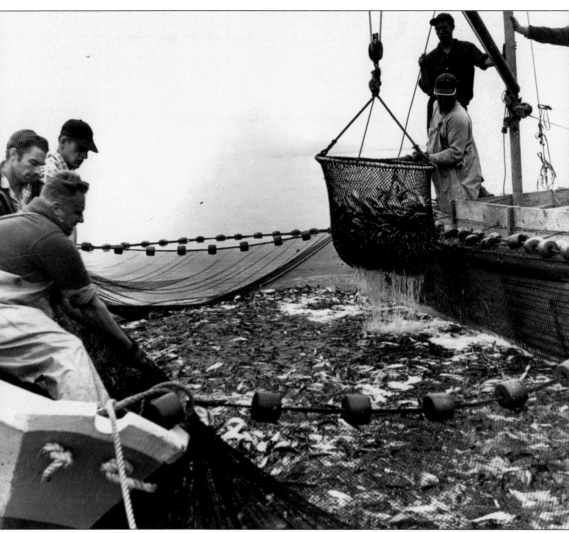

Caught herring were transferred into the seining boat, which brought them to the dock for use as bait or for processing at the fish plant. Sardine companies successfully lobbied to outlaw torching for herring at night, but Vinalhaven fishermen continued to seine in daylight hours for herring until the late 20th century using small double-enders and a drawstring purse seine. (Courtesy of Dick Mathews.)

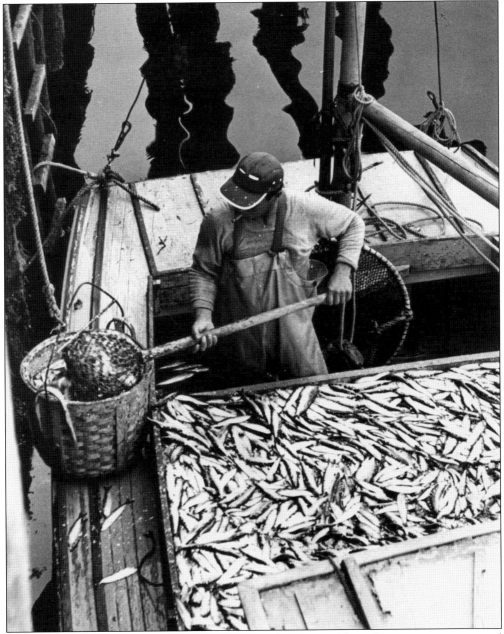

Louis Richards unloads herring at the C.L. Bickford Company. Tons of herring were consumed as bait for the lobster fishery. (Courtesy of Dick Mathews.)

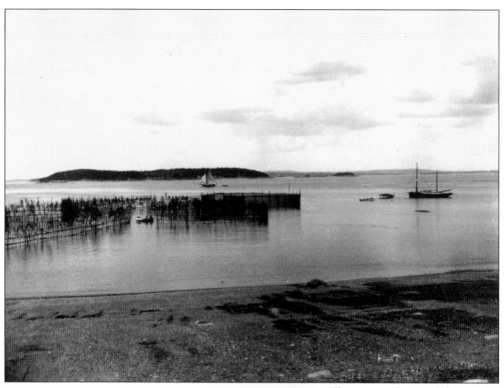

This image shows a fishing weir in the Red Sea, with Hurricane Island in the background.

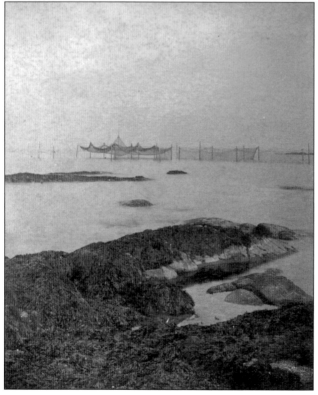

Schools of herring could be easily caught behind weirs with nets attached. Fish would swim into the weir and become trapped. (Courtesy of Maine Historic Preservation Commission.)

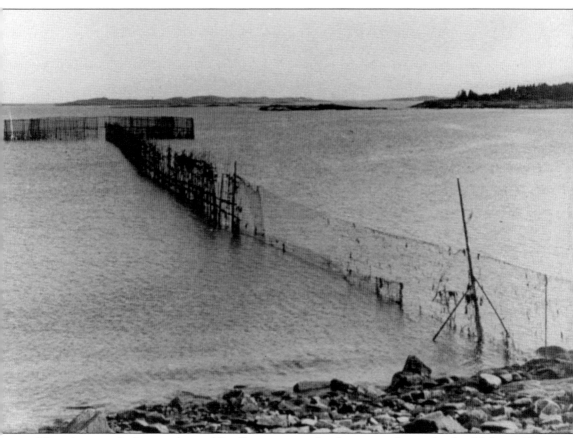

This photograph shows a weir at Vinalhaven, erected at locations where schools of fish would come in on a rising tide. Sidney Winslow reported that in the 1880s, Joe Rogers and F.M. Lane had a weir at Lane's Island, while Richard R. Arey and George Roberts had a weir near Wreck Ledge on the southeastern side of the island.

Weirs of wood and brush were built in tidal waters to trap herring.

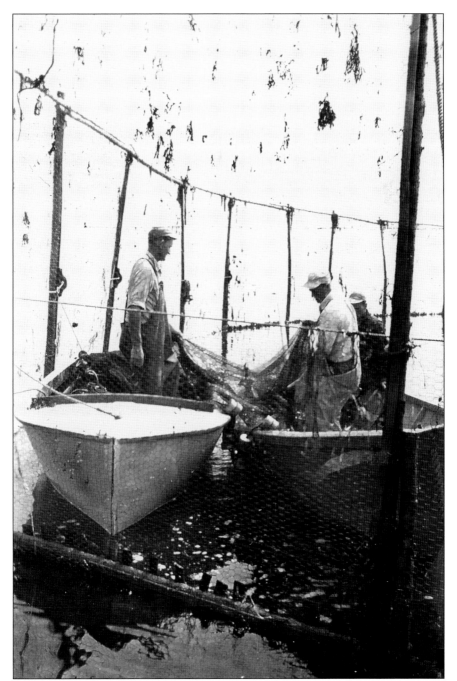

These men are drawing up a net full of herring between two double-enders at a weir in Hurricane Sound in the 1940s. Though this photograph was clearly taken during the day, one Vinalhaven fisherman told the author about torching for herring when he was a boy: "you take two double-enders and stretch a twine between them. You take a third boat and put a bag on the end of it and soak it with gasoline and light it. Then you row as fast as you can and run that double-ender boat between the other two boats. The herring will follow the light, they like to follow the light." Torching for herring was later outlawed. (Courtesy of Diana Roberts Gay.)

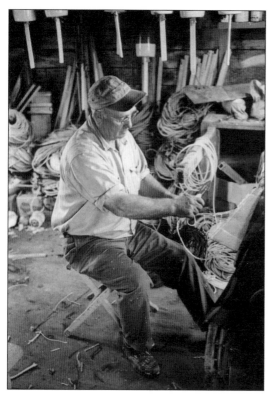

At left, Phillip Bennett is mending nets in his fish house. Simple gill nets were used to catch herring from small boats or in weirs. In the late 19th century, development of the drawstring purse seine net, equipped with floats and sinkers, made it possible to catch entire schools of herring.

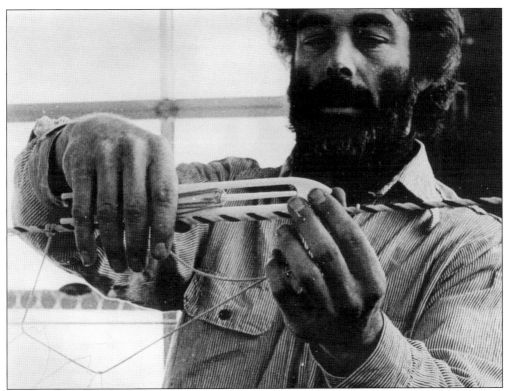

Robin Adair bastes fishnet to line using a net needle. Net needles came in a wide range of sizes and were handmade, usually out of wood. (Courtesy of Charlotte Goodhue.)

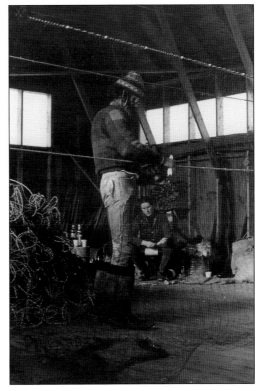

In Beckman's shop, fishnet was basted to a top line buoyed by floats. The bottom of the net was basted to a line containing lead sinkers. Cheryl Adair (background) fills net needles with twine to attach cork floats to the top line. (Courtesy of Charlotte Goodhue.)

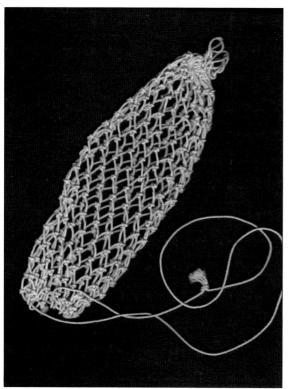

Bait bags (shown here) and pot heads for lobster traps were knit at home by men and women during the winter months. A pot head is an hourglass-shaped net covering the entrance to a lobster pot (trap) that allows easy access, but difficult escape, for the lobster. Bait bags were an innovation in the late 19th century, replacing iron stakes called pot spears.

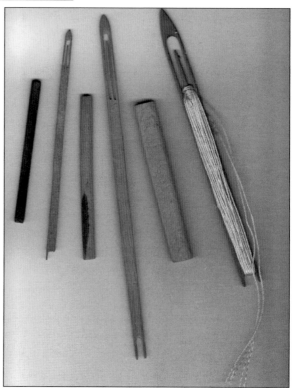

An assortment of wooden netting needles and spacers of various widths were used to make fishnets.

Elsie Calderwood is shown netting in this late-20th-century image.

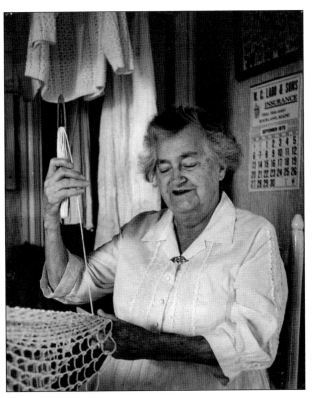

Elsie Calderwood sits at her net stand with a swift (which holds the twine without getting tangled), making a fish net.

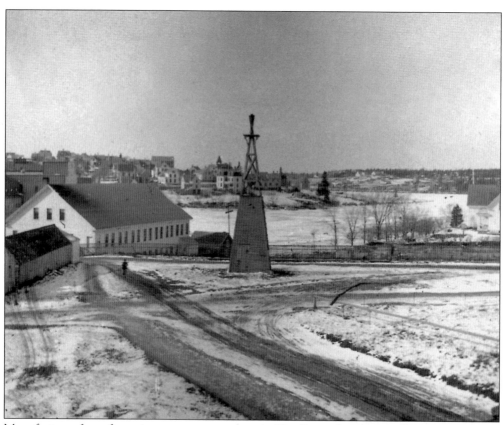

Manufacture of nets for various purposes was done in Vinalhaven homes as well as mass-produced in the net factory, shown in this photograph taken from the back side looking across Carver's Pond about 1900.

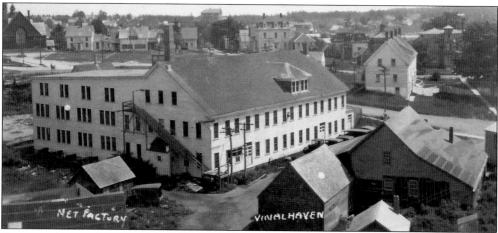

A postcard view of the net factory shows the large west wing. Production of nets for fishing and to protect horses from bothersome flies was an important part of the island's economic life from 1847 until 1926.

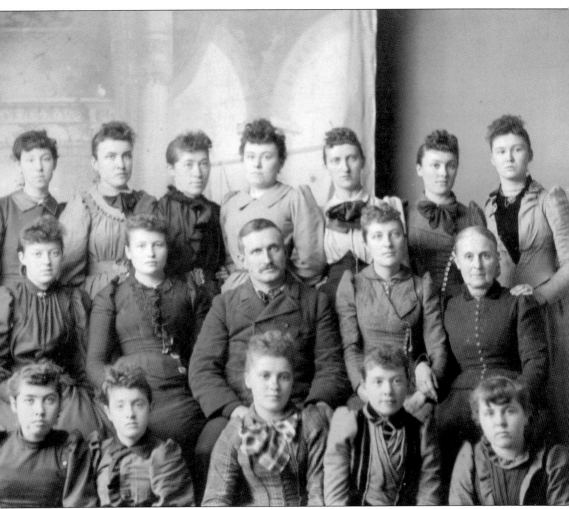

This early image shows net factory workers with their supervisor. From left to right are (first row) Alda Winslow Sprague, Mary Shields, two unidentified, and Etta Ingerson McKay; (second row) Amanda Smith Morton, Maggie Lane, supervisor Edwin Roberts, Sarah Smith Butler, and Eliza Ann Brown; (third row) May Rolfe Pierce, Gertrude Ewell, Carrie Hopkins Burns, Aurora Randall, Harriet Hopkins, Villa Brown Sprague, and Susan Delano Calderwood.

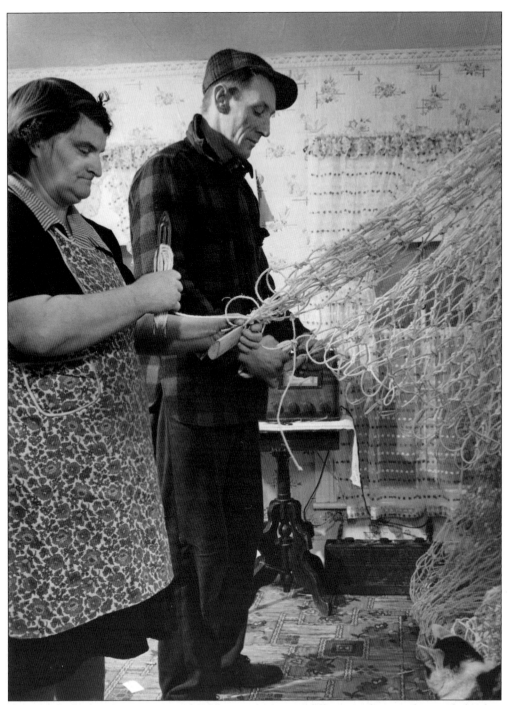

Orren and Florence Swears are pictured here making nets, following a long tradition of islanders making nets in their homes, both as piecework for the net factory as well as manufacturing and repairing nets for fishing.

Four

CROSSING THE WATER

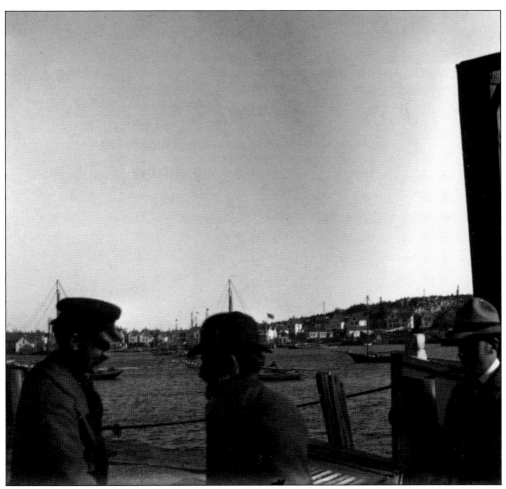

Three men waiting for the boat at Steamboat Wharf were captured in this glass-plate photograph about 1900.

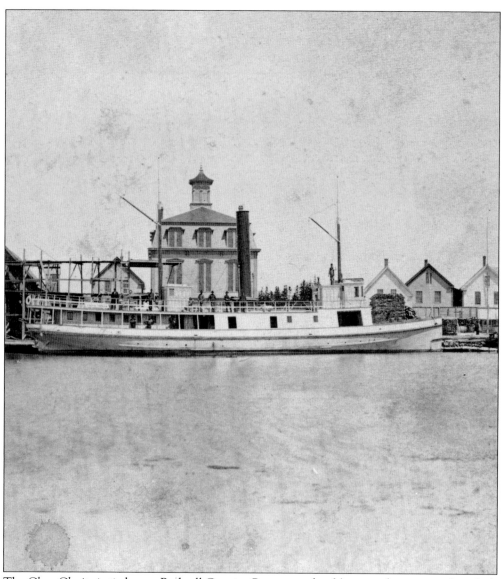

The *Clara Clarita* is tied up at Bodwell Granite Company wharf (present-day town parking lot). The first steamboat visited Vinalhaven in 1854. In 1867, the steamer *Pioneer* began regular service on the route between Vinalhaven and Rockland. In 1873, *Clara Clarita* and the side-wheel steamer *Ulysses* replaced *Pioneer*. Though speedy, *Clara Clarita's* service to the island was short lived; according to Winslow, she was "too deep of draught and too expensive to operate." The Fox Island and Rockland Steamboat Company put the slow but dependable *Pioneer* back on the route.

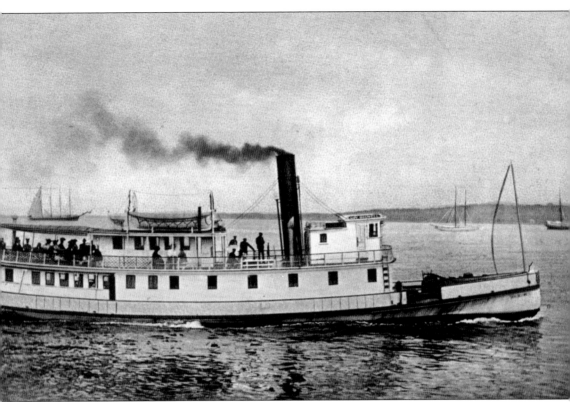

The SS *Governor Bodwell* was launched at Rockland on May 27, 1892, by the Vinalhaven & Rockland Steamboat Company. It ran between Vinalhaven and Rockland from June 30, 1892, to January 26, 1924.

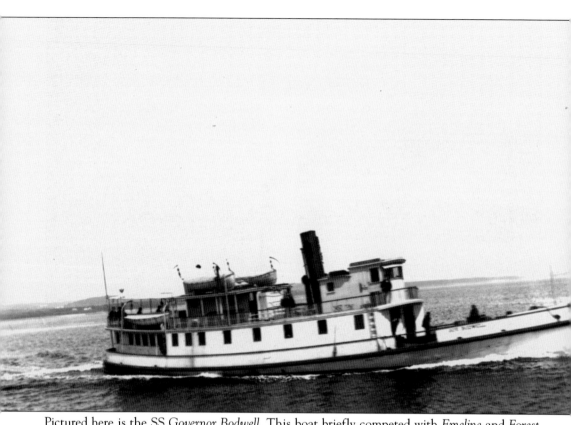

Pictured here is the SS *Governor Bodwell*. This boat briefly competed with *Emeline* and *Forest Queen*, owned by rival companies.

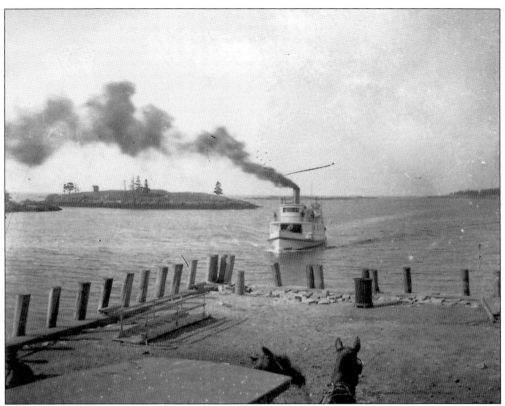

Even the horses waited patiently at Steamboat Wharf for SS *Governor Bodwell* to arrive.

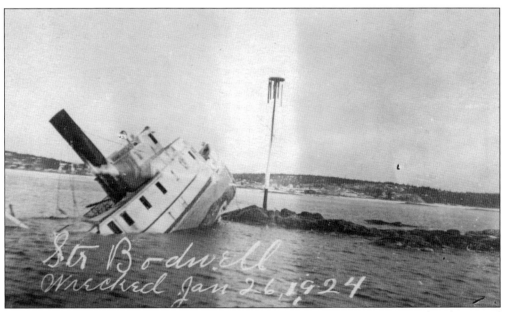

The SS *Governor Bodwell* wrecked January 26, 1924, but the steamer was restored and returned to service. On March 23, 1931, it caught fire while tied up at the dock at Swan's Island and was completely destroyed.

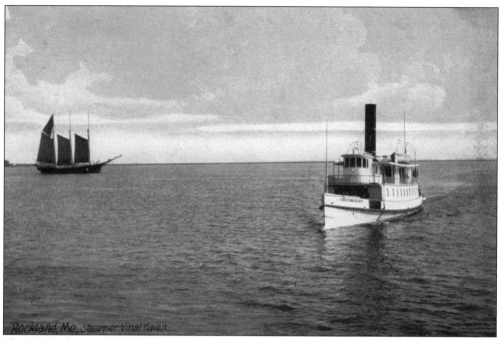

The SS *Vinal Haven* was launched at Searsport in June 1892 and began service to the island with William R. Creed as captain. *Vinal Haven* caught fire on January 13, 1892, but returned to service and operated until she was condemned in 1938.

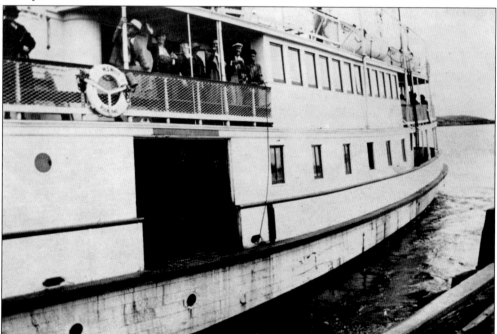

Formerly known as *Miramar* when she served Kingston, New York, the renamed *W.S. White* ran between Rockland and Vinalhaven twice daily during the summers between 1938 and 1942. The *W.S. White* was bought by the US Marine Commission and then leased to the US Army Corps of Engineers during World War II.

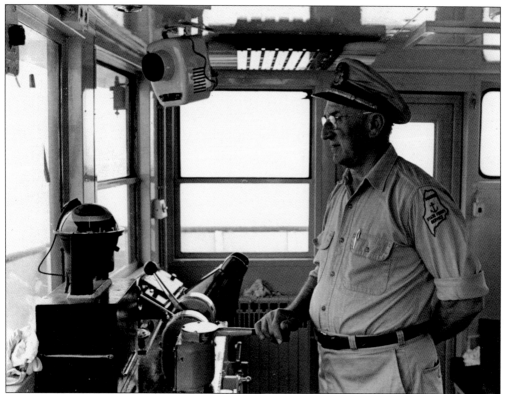

Capt. Charles Philbrook is pictured at the helm of the ferry *Everett Libby*. (Courtesy of Madelaine Philbrook Hildings.)

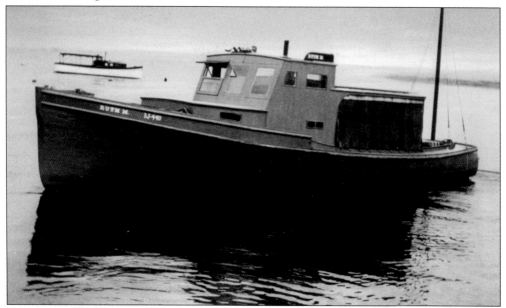

Captain Philbrook used his own boat, the *Ruth* M, to transport goods and people between Vinalhaven and the mainland for 18 months during World War II, after the ferry was put into government service for the war effort.

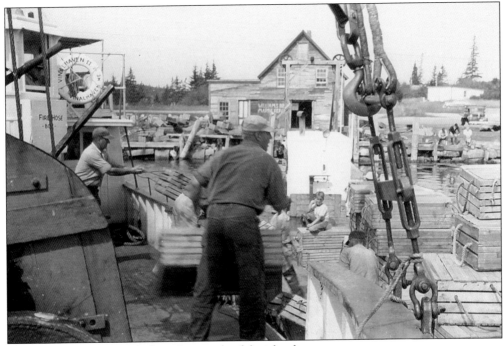

Vinalhaven II was a vital link to the mainland for island commerce.

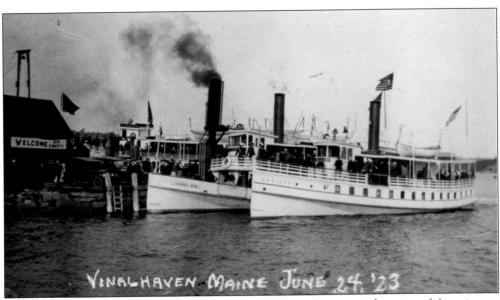

Steamboat Wharf was at the west end of Main Street, at the current location of Americanus lobster buying station. Shown tied up at Steamboat Wharf on June 24, 1923, are three ferries: *Castine*, *Golden Rod*, and *Pemaquid*.

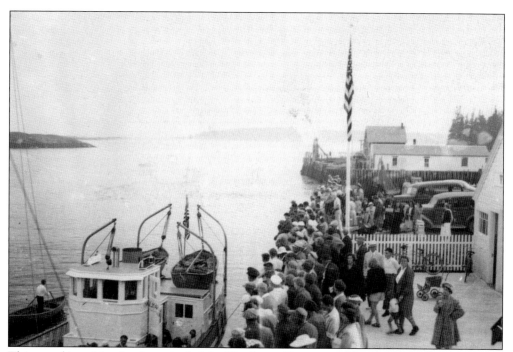

This crowd is waiting for the arrival of the *Vinalhaven II*, captained by Charles Philbrook. Built in 1943 in Southwest Harbor, Maine, at a cost of $53,000, the *Vinalhaven II* ran between Vinalhaven and Rockland from 1943 to 1960.

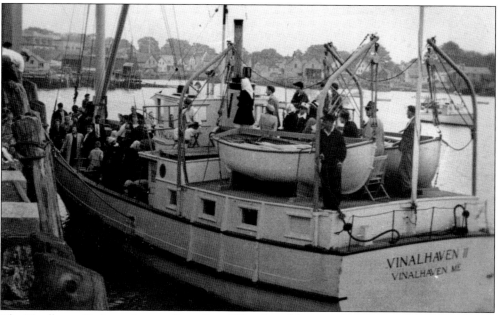

The *Vinalhaven II*, shown here at Steamboat Wharf, could carry two cars. It was eagerly awaited, funded by donations, built by Vinalhaven Port District, and began service on July 21, 1943.

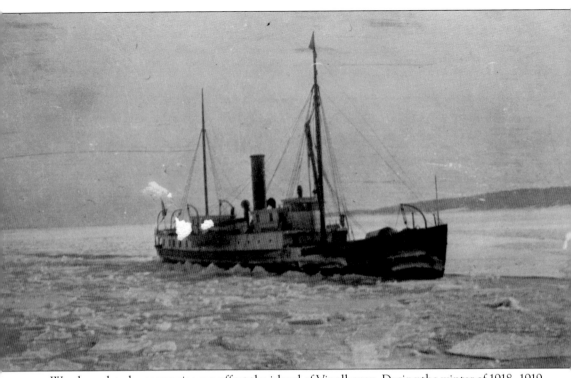

Weather-related emergencies can affect the island of Vinalhaven. During the winter of 1918–1919, Carver's Harbor froze solid and food ran short on the island. *Zizania* brought much-needed supplies for islanders.

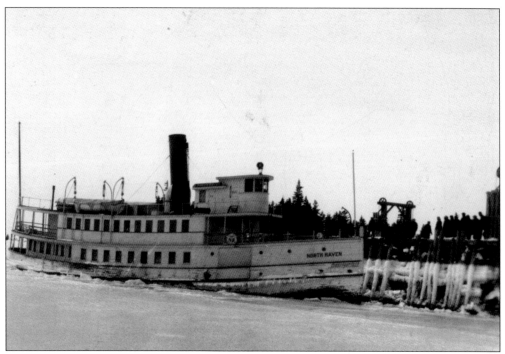

The ferry *North Haven* was frozen in ice at the dock at Vinalhaven during the harsh winter of 1918–1919, as seen in this postcard image. According to the US Coast and Geodetic Survey Pilot Guide of 1891, almost every year "ice during January and February closes the harbor but a channel is kept open up to the steamboat wharf."

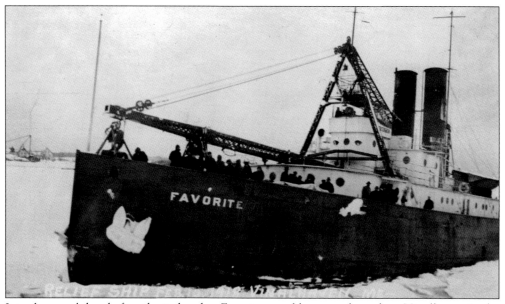

It took several days before the icebreaker *Favorite* was able to get through to Vinalhaven in the winter of 1918–1919.

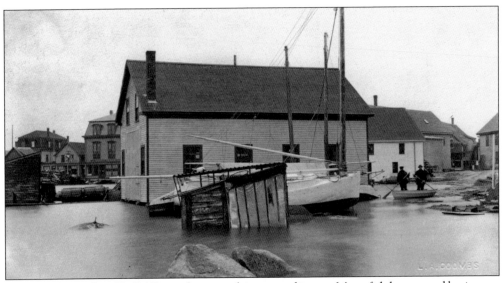

Flooding along Clam Shell Alley is shown in this postcard image. Many fish houses and businesses along the waterfront are occasionally affected by high tides.

Lunar high tides, accompanied by a strong south-southwest wind, create high seas and sometimes cause flooding around the waterfront. This postcard image was taken at high tide during the fall of 1945.

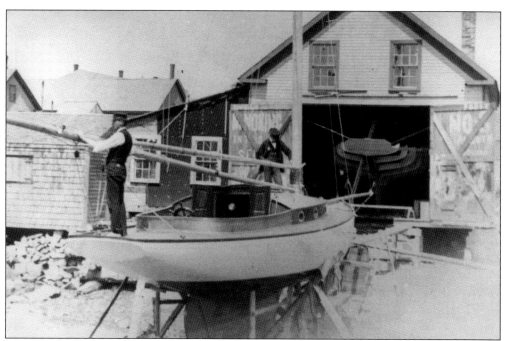

Weather can be hard on rigging. Boman's Sail Loft on Clam Shell Alley was a busy place. Charles and his father, Claus Boman, sail makers, are measuring what will be needed for the sails on one of Laroy Coombs's new boats. Reinhold Boman and his son Claus were operating the Sail Loft as early as 1873.

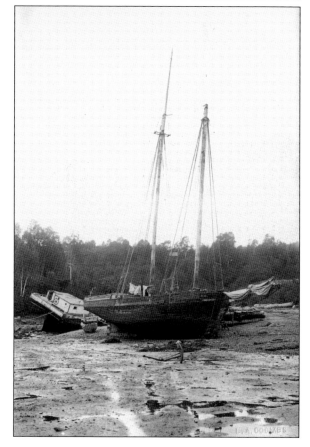

This schooner may have been abandoned, since it is not in a cradle.

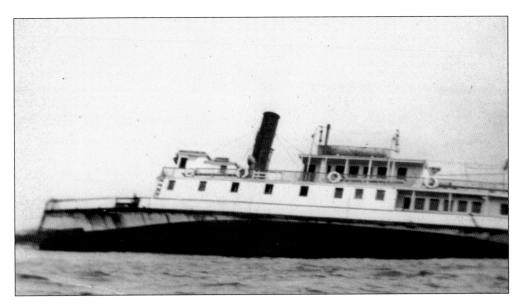

Pictured here is the wreck of SS *Castine* on June 8, 1935.

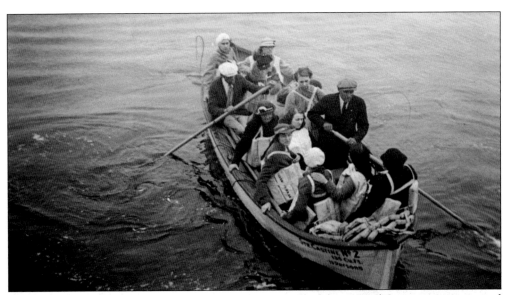

The SS *Castine* lifeboat No. 2 had a capacity of 13. Not all of the rescued *Castine* passengers and crew donned the life preservers that were stowed in the bow of the rescue boat.

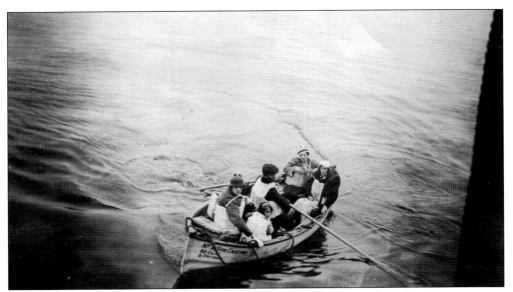

The SS *Castine* lifeboat No. 1 had a capacity of six persons. Note the bulky life vests worn by passengers.

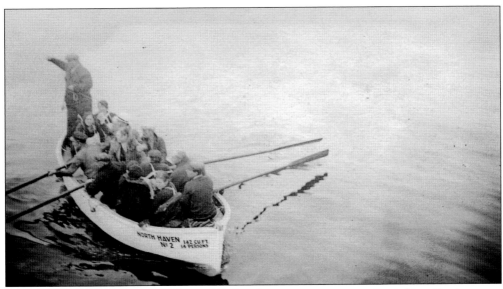

A lifeboat from the ferry *North Haven*, filled with passengers, escapes the sinking *Castine*.

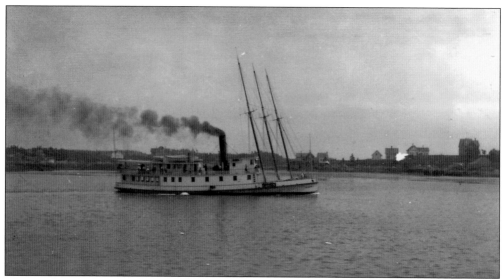

This unidentified steamer assisted a schooner tilting with "a cant towards sawyer." Vinalhaven is wreathed with shallows and ledges, treacherous for mariners unfamiliar with the area. A pilot's guide published by the US Coast and Geodetic Survey advised mariners in 1891: "It is impossible to give directions that would be of practical use to a stranger in these confined waters." Arey's Cove was "full of dangers" while Winter Harbor, Seal Bay, and Smith's Cove were "of no commercial importance" and "unsafe for a stranger to enter."

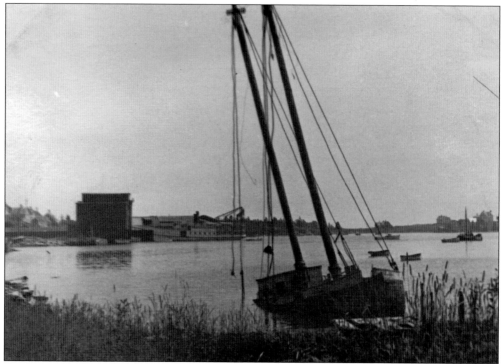

A schooner is shown wrecked in Carver's Harbor near the Lane and Libby fish plant sometime after 1909. Accidents due to weather and navigational hazards were an ever-present risk in maritime ventures.

Five

LIGHTING THE WAY
TO SAFE HARBOR

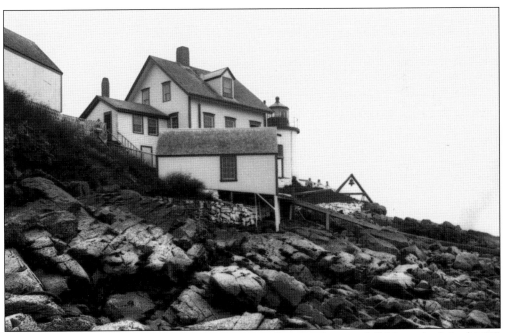

Brown's Head Lighthouse, shown in this glass-plate photograph around 1900, was built for $4,000 in 1839 to help guide mariners through the western entrance to the Fox Islands Thoroughfare. Business owners and marine insurance companies pressured Washington politicians for lighthouses to protect investments in large vessels and cargoes of codfish, granite, lumber, and market goods for Maine's growing population. The fishery and coastal trades were supported by the lighthouse system, which warned mariners of hazards to navigation. In 1789, the federal government absorbed private lighthouses previously funded by tariffs. In 1843, I.W.P. Lewis reported to Congress: "The commerce of Maine is now sufficiently important to require every aid and facility to navigation that can be obtained. Her tonnage already ranks next in amount to Massachusetts and New York, and her hardy seamen have more dangers to contend against in approaching these shores than on any other portion of our seaboard."

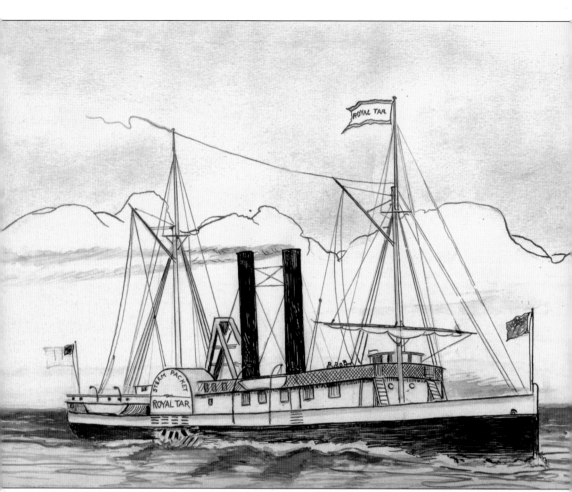

This is an imaginative drawing of the side-wheel steamship *Royal Tar*, which caught fire and sank in a gale off Vinalhaven's eastern shore on October 25, 1836. Contemporary newspapers sensationalized Capt. Howland Dyer's valiant rescue of scores of drowning passengers with the revenue cutter *Veto*. Throughout the mid-19th century, lighthouse keeper positions were often awarded to individuals with political connections or popular sympathy. Captain Dyer was appointed keeper of Brown's Head Light in 1843. At the time of his appointment, the Brown's Head station had been in operation just over a decade. Dyer enjoyed a remarkably long tenure as keeper at Brown's Head Light, from 1843 to 1864.

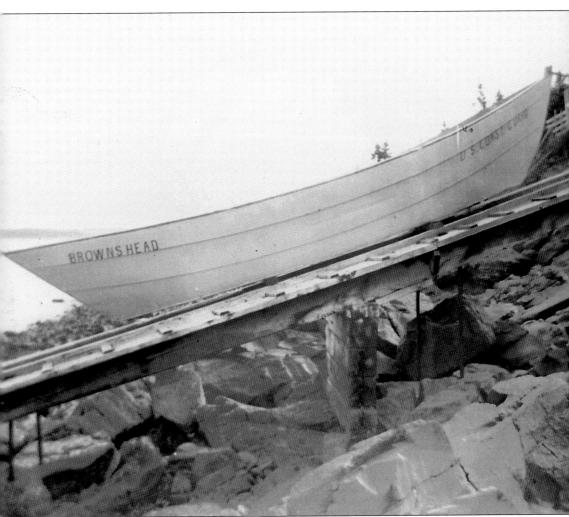

Pictured here is the rescue dory for Brown's Head Light. Lighthouses could not prevent shipwrecks caused by negligence or wind driving sailing vessels off course into navigational hazards. Lighthouses reduced shipping losses in places where visibility changes very quickly, dense fog banks move in faster than a small boat can reach shore, sudden blinding snow squalls blow in without warning, and wisps of winter sea smoke condense and rise over cold water. The commercial mission of the lighthouse system was not always obvious to the general public, because sensational newspaper articles about shipwrecks focused on rescue, particularly if lives were lost. The US Lighthouse Board was formed in 1852 and merged with the Coast Guard in 1915. (Courtesy of Roger W. Young.)

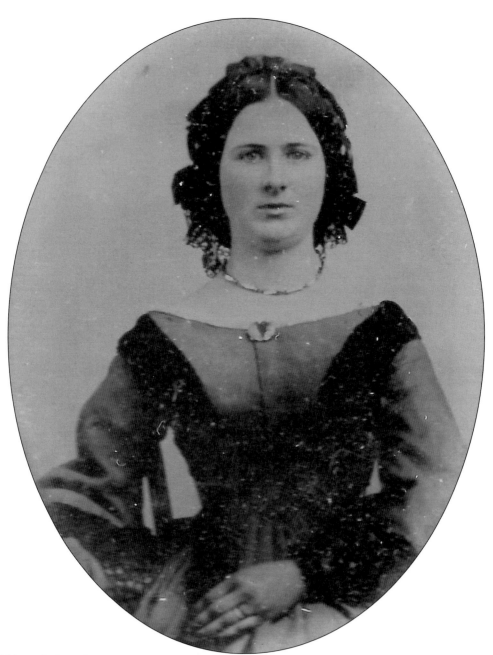

Aldana C. Dyer, born February 1, 1847, was the daughter of Brown's Head Light keeper Howland Dyer. Her father captained the revenue cutter *Veto* and saved survivors from the burning *Royal Tar*. Howland Dyer and his wife had three children when he was appointed keeper of Brown's Head Light. Five more children were born to the couple while he was the keeper, including Aldana, who grew up at Brown's Head Light. When Dyer's last child was still a toddler, the present-day keeper's house was constructed, in 1857. Two years later, on January 15, 1859, Dyer noted the "sistern sprang a leak and the water all leaked out." It takes little imagination to understand what a privation that might present to a family of two adults and eight children. (Courtesy of Roger W. Young.)

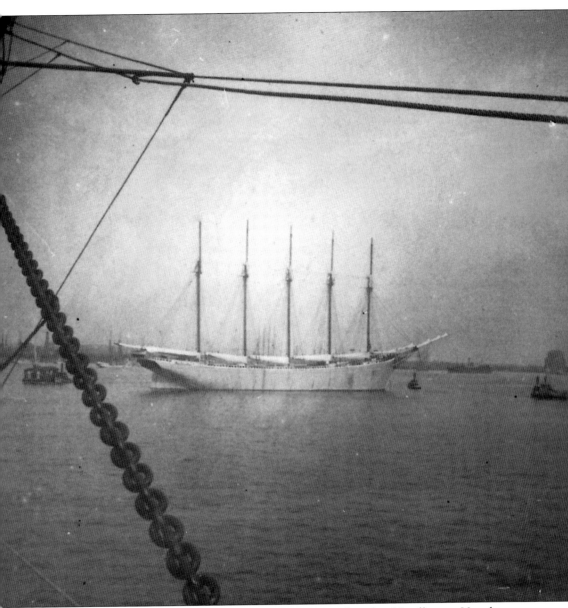

This glass-plate photograph of a five-masted schooner was found at Vinalhaven. Vessels were classified as ships, barks, brigs, schooners, or steamers in the *Journal of Vessels* kept by Howland Dyer at Brown's Head Light from August 25, 1856, to December 31, 1863. His entries were transcribed from tallies made throughout the day on a log slate, which must have required constant vigilance as thousands of vessels passed the light station every year. In 1857, the first full year of the journal, Dyer sighted 5,067 passing vessels, including 4,478 schooners, 481 sloops, 57 brigs, 50 steamers, and 1 ship. Six years later, just before the end of the cod fishing boom, traffic had more than doubled. Dyer reported sighting 11,127 passing vessels, including 10,008 schooners, 886 sloops, 220 brigs, 12 steamers, and 1 bark. The keeper's journal included daily notes on wind speed, wind direction, visibility, and precipitation. Many years, in mid-January, Dyer reported "ice in passage," followed days or weeks later by "passage clear of ice." Quarterly reports were compiled from the journal and submitted to the district lighthouse inspector.

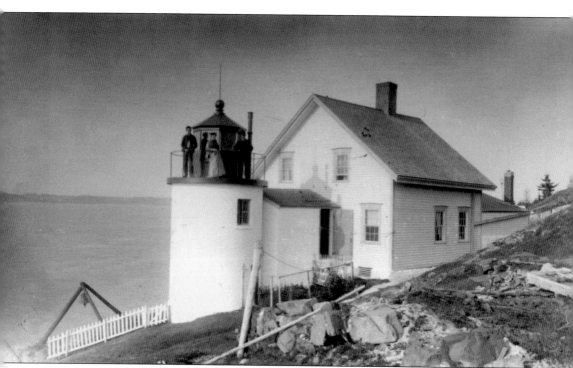

Brown's Head Light, shown here around 1900, was a government facility and therefore open to the public during daylight hours. A lighthouse keeper was expected to welcome visitors while continuing to tally passing vessels, perform routine maintenance, and light the lamps.

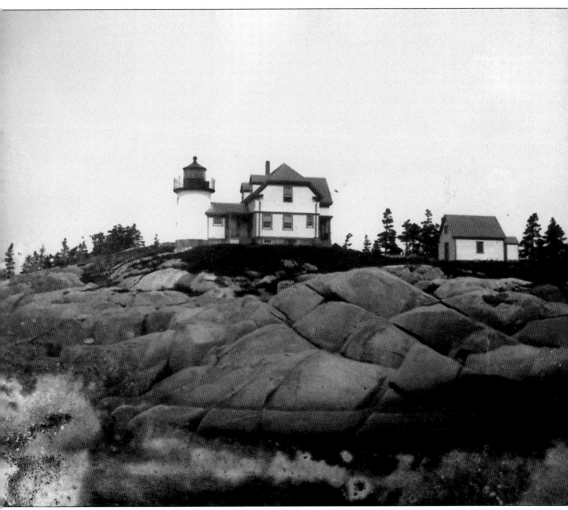

In 1854, Heron Neck Lighthouse was established on Green's Island at the east entrance to Hurricane Sound, to help guide mariners heading for Vinalhaven's Carver's Harbor. Much political wrangling preceded selection of a site for a new lighthouse. Hannibal Hamlin, US senator from Maine, wrote to David Vinal of Maine's House of Representatives on March 9, 1852: "I will endeavor to procure an appropriation for a Light House at the place you name and I think I can be able to accomplish it." Senator Hamlin wrote again on April 12 of the same year, saying "your bill has passed the Senate so strong I presume it will pass the House." Heron Neck Light was automated in 1982, and the Coast Guard keepers were removed. In January 1988, it was listed in the National Register of Historic Places and is currently in private hands.

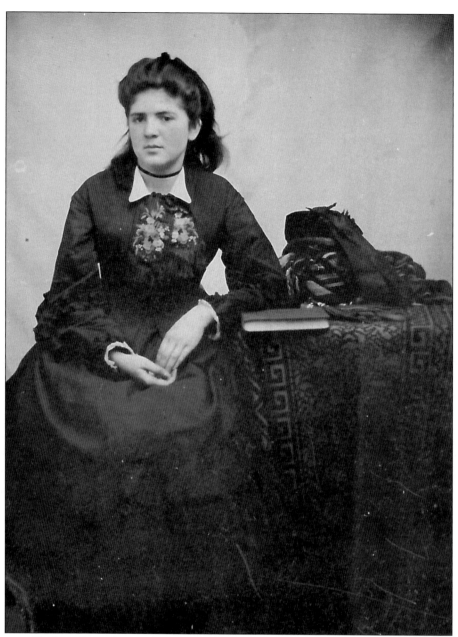

Margaret Hopkins Kittridge was born at Saddleback Light on September 14, 1843. As a week-old infant, she accidentally slipped from the arms of someone boarding a boat to take the baby off Saddleback. She fell into the turbulent cold water that laps the rocks at Saddleback, but was quickly rescued and survived to live a long life. Her father, lighthouse keeper Watson Y. Hopkins, testified in a report to Congress in 1842 about the many privations of living with a family at remote Saddleback Light: "I was appointed keeper of the light, December 1839, upon a salary of $450. I live with my family in the tower, which is the only building on the ledge . . . I am obliged to bring my water from shore, a distance of seven miles . . . I am obliged to pay freight on my supplies on account of not having a suitable sail boat to bring them with myself. My family consists of nine persons . . . the privy . . . was carried away the first storm after its erection."

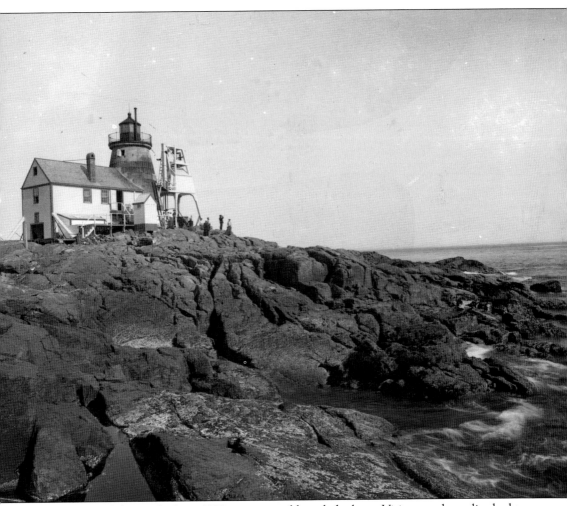

Saddleback Lighthouse, built in 1839, was accessible only by boat. Visitors and supplies had to be moved from the boat to a boatswains chair attached to a boom. Keepers also maintained lighthouse structures exposed to water and gale-force winds, constantly repainting and replacing rotted wood. In 1874, Saddleback Light had two sides of the boathouse sheathed and painted, and the boat slip was repaired with new timbers, rollers, and slides, most likely completed by the keeper himself, according to a report by the US Lighthouse Board.

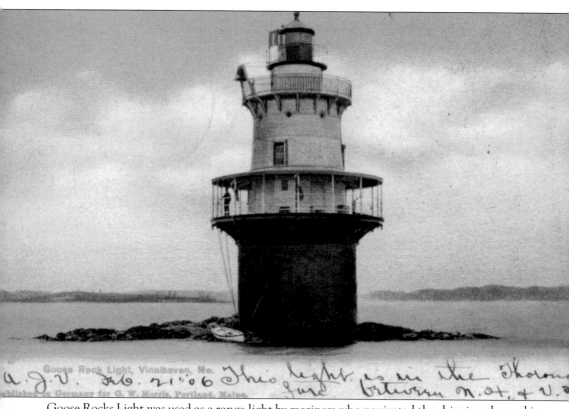

Goose Rocks Light was used as a range light by mariners who navigated the shipping channel in the passage between North Haven and Vinalhaven by lining up with the central white lens that was bracketed between two red lenses. The light also marked a navigational hazard. According to a pilot guide published by US Coast and Geodetic Survey in 1891, "Goose Rocks lighthouse is on the north side of the channel, north of Widow's Island; it is the guide for the eastern entrance of the Thoroughfare and for the anchorage in Kent's Cove."

Proximity to Carver's Harbor and open water was a significant competitive advantage for Vinalhaven's granite quarries, which shipped to many faraway ports. The General Wool monument was transported on the lighter *Jemima Leonard* from Bodwell Granite Company yard at Sands Cove. (Courtesy of Maine Historic Preservation Commission.)

The Bodwell Granite Company Wharf (upper left) is the present-day town parking lot. It was constructed to receive products for the large company store and an associated business selling lumber, wood, and coal. This photograph was taken from Clam Shell Alley around 1900.

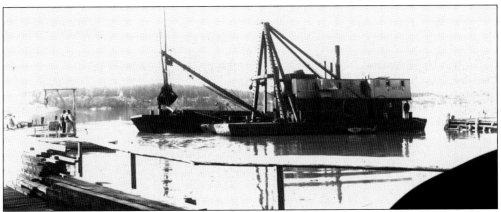

The *Plymouth Rock* cleared Carver's Harbor, which was so "much obstructed by rocks and ledges" that "a stranger should not enter without a pilot." A guide published in 1891 by the US Coast and Geodetic Survey noted, "pilots are on the lookout from shore and will come out to vessels making signal when the weather and sea permit. Strangers should lie off and on about 1 1/4 to the southward of Heron Neck Light until boarded . . . Sailing directions of practical value to a stranger cannot be given."

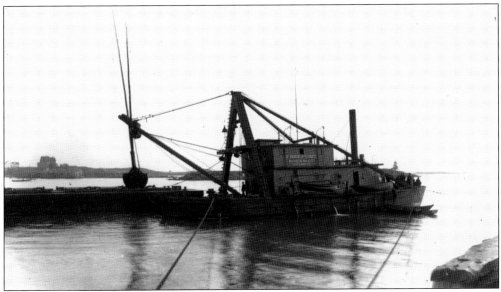

The *Freeport* also dredged Carver's Harbor. According to the US Coast and Geodetic Survey Pilot Guide of 1891, the channel was "narrow and crooked and requires some local knowledge to take a vessel to the anchorage, which is small but well-sheltered against all winds and has a depth of 10–20 feet, soft bottom."

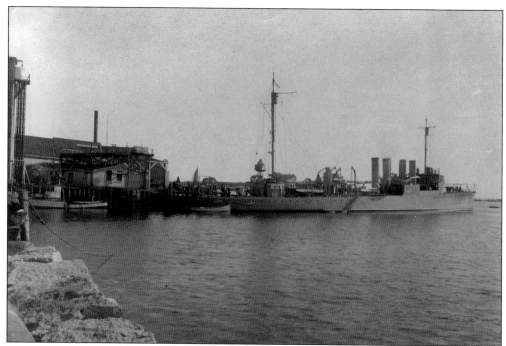

It took quite a bit of skill as well as knowledge of Carver's Harbor to pilot the *Caldwell* safely to dock in Carver's Harbor on Labor Day 1921. Vinalhaven native, pilot Walter Tolman, achieved the feat.

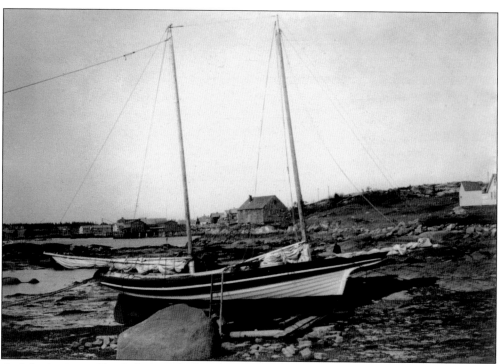

A pinky is pictured hauled up on the beach in Carver's Harbor.

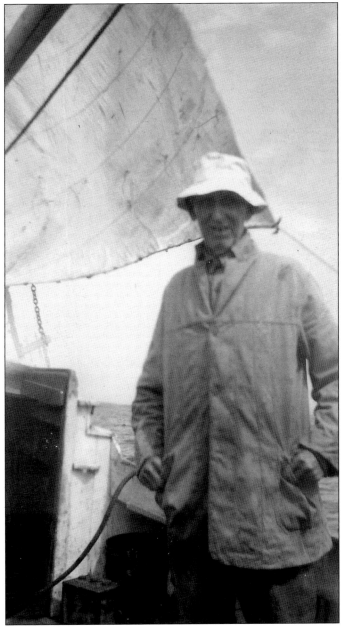

Fisherman William "Willie" Horace Burns navigated expertly by lining up landmarks on the horizon long before the advent of satellite-guided electronic devices. Fishing territories were known either as the piece associated with a fisherman or called by the name of the ledge, reef, shoal, ridge, or ground beneath. For example, Camden Ground at 22 fathoms was found "to the Eastward until the notch on Eastern Ear begins to show and Vinalhaven Standpipe comes in the notch on little Brimstone Head." The Willie Burns Piece was "Lincolnville Mountain off Brimstone and Northern Mount Desert Hill over little isle in Eastern Bar gut." Vinalhaven's fishery and related maritime industries were built on natural resources so abundant they were considered infinite until very recently. But those resources could not have been harvested without the intimate knowledge of terrain and environment gained only from generations rooted in one small place.

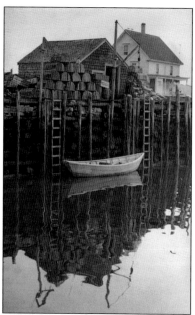

Robert "Bob" Tolman's 16-foot yellow Novi, the *Leman-aid*, is tied up at T-Dock. Bob used this tender to row out to his lobster boat (also painted yellow), the *Leman*. The fish house belonged to Richard and Robert Tolman and was moved to City Point around 2005, when the wharf was repaired. This is still a Tolman family wharf.

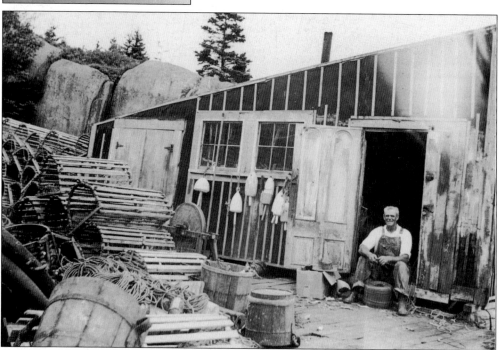

Al Miller poses in the doorway of his fish house on Lane's Island. Pot buoys like those displayed on his fish house marked the location of a lobster pot and indicated the owner by identifying colors. Roger Young's uncle made square pot buoys out of cedar cut in winter months from a swamp near Barton's Island. Cedar was preferred over pine because it would not get waterlogged and sink. Some fishermen preferred square-sawn buoys to round ones turned on a lathe, on the principle that flat ones would not twist the line. As the number of lobstermen increased in the state of Maine, pot buoys were branded to display the fisherman's name or (in recent years) state lobster license number.

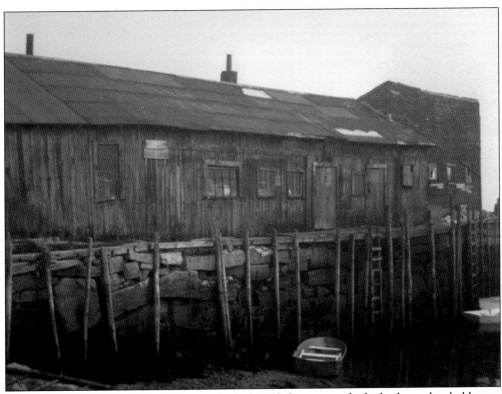

Pictured here is Walter "Shag" Ingerson's dock. Fish houses on docks had wooden ladders to access punts or tenders tied alongside, and at low tide, wooden ladders with rotten or missing rungs, green with slippery algae, and dotted with barnacles, mussels, periwinkle snails, and an occasional small whelk made a hazardous 10- or 12-foot climb. The fish house was a storage shed for fishing gear, line, buoys, and salt, and was an exclusively male domain. Most fish houses had some rudimentary seating, one or more rusty cans for spitting chewing tobacco, a few brown glass bottles for "teatime," and perhaps a slab of dry salt fish hanging by the door for a visitor to slice off a bit to chew. (Courtesy of Frank Caffrey.)

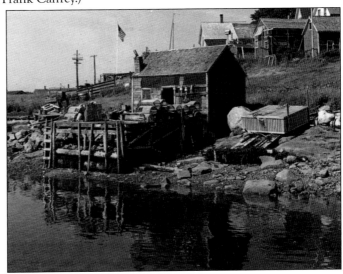

This is the rocky east side of Carver's Harbor, on Fred Greenlaw's Cove. This wharf was formerly owned by Charles Young and passed along to his son-in-law Ralph Doughty. The current owner is Jerry Doughty, Ralph's grandson. The small wooden float on the right could hold up to 1,000 pounds of lobster.

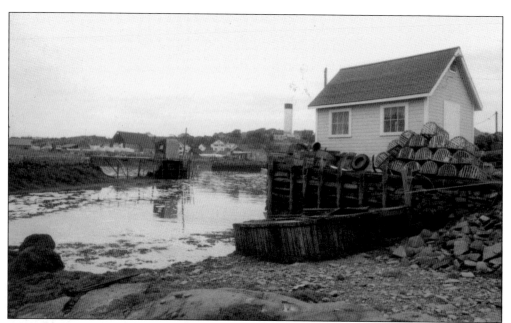

Around 1950, this fish house was built by Roy "Busky" Ames to store bait. It was later sold to Frank Osgood, then to Jack Olson, who moved it to the right of this location.

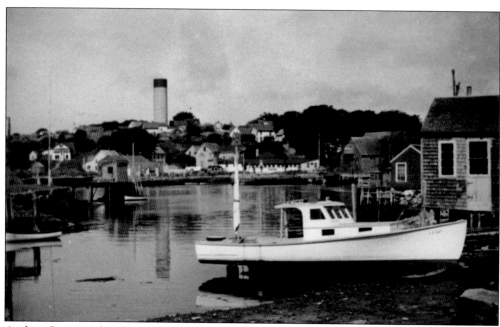

Andrew Bennett's boat ground out in front of Carroll Gregory's boat shop. The riding sail in the stern was used to steady the boat when trawl fishing. Bennett was the last civilian lighthouse keeper at Heron Neck Light.

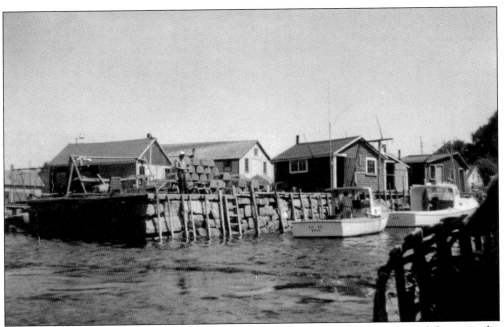

Ken Hatch's lobster boat, the *Viv, Sis, and Brud*, is pictured here in front of his fish house at the end of present-day Leo's Lane, about 1958.

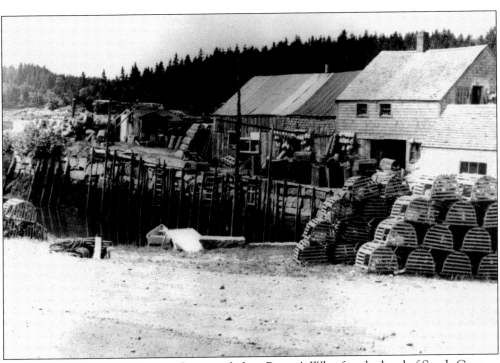

Wooden lobster traps are waiting for use, piled on Brown's Wharf at the head of Sands Cove.

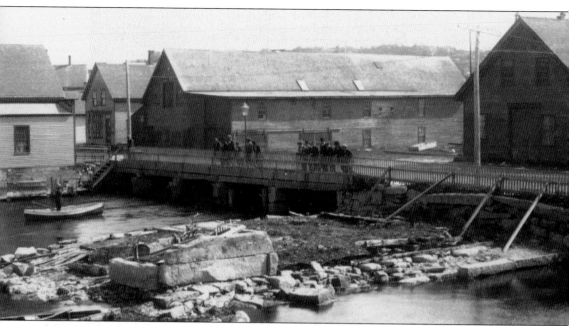

Men watch fish flipping in the tidal Mill Stream around 1900. People still fish from the bridge over the Mill Stream, but these days, the fish are scarce.

Vinalhaven native Leonard "Buddy" Skoog summed up changes he has witnessed in the fishery during his lifetime: "We used to go hand lining in a Goudy in the last part of May, early part of June, on the western end of Seal Island. You could be out there at daybreak and in two hours you could have six or seven hundred pounds of pollock. You didn't even need any bait, just two Swedish pimples on the line and drag them in. But when they made the big drags with the big boats, they broke up the schools of herring coming in to spawn. They took them all and the herring didn't return. They made a lot of money, but it killed fishing." The next chapter of maritime industries on Vinalhaven depends on sustainable practices to restore the fishery now, for the use of generations to come.

DISCOVER THOUSANDS OF LOCAL HISTORY BOOKS
FEATURING MILLIONS OF VINTAGE IMAGES

Arcadia Publishing, the leading local history publisher in the United States, is committed to making history accessible and meaningful through publishing books that celebrate and preserve the heritage of America's people and places.

Find more books like this at
www.arcadiapublishing.com

Search for your hometown history, your old stomping grounds, and even your favorite sports team.